T0354147

The Latitudes of

Silence
A Voyage Across the
Pacific Ocean

 Trafford PUBLISHING® www.trafford.com

North America & international
toll-free: 1 888 232 4444 (USA & Canada)
phone: 250 383 6864 ♦ fax: 250 383 6804 ♦ email: info@trafford.com

The United Kingdom & Europe
phone: +44 (0)1865 487 395 ♦ local rate: 0845 230 9601
facsimile: +44 (0)1865 481 507 ♦ email: info.uk@trafford.com

10 9 8 7 6 5 4 3 2 1

To my dear wife, Petra, and my brother Sebastian, the pillars of my existence.

"It is a commonplace of all religious thought, even the most primitive, that the man seeking visions and insight must go apart from his fellows and live for a time in wilderness. If he is of the proper sort, he will return with a message. It may not be a message from the god he set out to seek, but even if he has failed in that particular, he will have had a vision or seen a marvel, and these are always worth listening to and thinking about."

Loren Eiseley, *The Immense Journey.*

There was a void in everything that day.

As soon as the meeting ended, I went back to my office and closed the door behind me. Out the window, several floors below, I saw the lights of the evening traffic flowing slowly through the fog.

"Like miners coming to the surface after a shift, faceless shadows led by headlamps in an Indian row procession," I thought.

I switched my iPod on and sat in my executive chair. A lazy trumpet, a piano, the light of a green desk lamp, and me there, in a white shirt and dark-blue pants, feet on the table, eyes closed. After a long while I looked at the dark profile shadowed on the wall and wondered what would become of that man. How had he ended up there, in that cell high above the steaming city, in darkness, feeling empty inside, hollow, like a dead old tree?

I closed my eyes again and off I went.

French Polynesia. Tropical night with more stars than the sky could hold. Palm trees swaying gently in the warm breeze. A boat at anchor in the bay. Vahinas dancing on the beach around a fire. Sweaty bodies moving on the rhythm of the drums. Muscles flexing and ancient beat of human existence. Rhythm of Universe. A fugitive in the cockpit watching everything in trance. An escapee from another world.

The phone rang and it startled me. Back in a dark office in a big gray city. The trumpet stopped playing. There was no sound but the generators pumping heat through the pipes.

I listened quietly to the news at the other end. A friend of mine, CEO in a development unit in China, had collapsed and was in critical condition in a hospital there. Katarina, his wife, wanted me to accompany her to Hong Kong. No one knew the cause. He had been found sitting on his sofa, in front of the TV, unconscious. I hung up. My secretary came in and handed me

the e-tickets. It all had been arranged. I made a few phone calls and went downstairs where an idle taxi was waiting.

And upstairs, on my desk, there was an unmarked envelope with my resignation letter.

Bo was a very dear friend of mine, we shared many unique memories, Africa, Sweden, China, climbing mountains together, dreaming, racing on the highway, eating big dinners, drinking wine and threatening each other with escape plans. I was not alone. There were other prisoners out there, planning their Great Escape. In fact I was quite sure there were many office slaves out there, from Wall Street to Tokyo, London and Frankfurt, many of whom were dreaming of a simple life in the country, "perhaps open a bakery," they'd say, or "I'd like to work with wood, furniture maybe." These were executives, bankers, software engineers, bureaucrats, people with degrees and MBAs.

Bo had been an Olympic athlete in his youth and ended up climbing the corporate ladder after receiving his Master of Engineering in Electronics. He still trained without mercy, running 10k, and then biking 60, coming home almost dead. Almost dead was the only kick we could afford time-wise, and it was also a way of deleting the demons. The politics at work, the vicious bloodbaths in the quest for power, the building of empires, all that takes a toll on people. Bo was particularly extreme in his way of punishing his body because he was a man of conscience and great integrity. Exhaustion and near-death experiences seemed to purify his mind. But his stunts were almost suicidal. He'd play with death like a killer whale with a seal pup. He'd drive on the highway and close his eyes and count the seconds. He told me his best was twelve seconds, blindfold at 130km/h.

Then he went to China. He needed a change. Once in a while he'd call me asking for "oxygen." We talked and talked and he always seemed to feel better after our conversations. I used to tell

him, "remember, it's only a question of time, be patient, it will happen. We'll be free someday." But I worried about him.

As I wrote those words on my laptop, Katarina fell asleep exhausted, her head resting on my shoulder. The plane was taxing on the runway, waiting for clearance from the control tower.

I worried about her. In every life there's a sense of unfulfillment, someone said.

Hours passed. I kept drinking across the meridians, all the way to Greenwich and beyond, and my head was light.

We were flying over Siberia. I looked out into the darkness and saw dots of light concentrated in small circles. Circles of humanity. Circles of human destiny with all it implied, joy and sorrow, hope and despair.

Hong Kong was a sauna. It was midnight and the city exhaled steam like a dragon. The small islands around the coast of Mecca glowed in the dark and millions of lights reflected from the mirror of the still water. The South China Sea looked like a frozen sheet of ice, smooth and glassy. David and Sylvain, Bo's right and left hand lieutenants waited in a limo outside the airport exit. We drove on suspended highways and there was a gigantic yellow moon right ahead of us. We almost bumped into her a few times but she was elusive and distant, floating away, always away, like one of those Chinese lamps that rise to the sky with a burning candle inside, can't remember what they're called.

We went through the border with Guang Gzhou and a great mass of people went through the gates with us. Old Communist buildings lie derelict among the steel and glass towers of newborn capitalism. Red letters on thirty-foot slogans are missing or hanging upside down. The times, they were a'changin'.

The car pulled up in front of the hospital. The elevator was jammed full. People coughed. There was nowhere to hide. "This is where the word pandemic must have originated from," I thought.

We walked through corridors of yellow linoleum and green walls and then we came to a stop. We were told to wait outside a door. No one talked. The door opened and Bo was brought outside on a mobile bed. IVs and tubes and wires dived into his body like fresh-water leeches. His wife leaned over him and whispered in his ear. He nodded yes and looked into her eyes. Then she turned towards me and beckoned me to come closer. He took my hand and pulled me close.

"This time I pushed it too far."

Bo had seen Death up close and personal. White, flickering neons buzzed overhead. It was a cold and sterile scene from a Scandinavian film of suicide and despair. I felt overwhelmed and left the room. Katarina sat next to him, still not crying, still holding on. No one knew what had happened.

The limo took us to Bo's hotel. We flew into space until floor 60, above the fog and the city below. The sky was white, like a Chinese funeral card. Uniformed, pretty Chinese women opened the door and waited outside, their hands kept together behind their backs. Katarina and I walked in. Big windows overlooking a few other towers that penetrated the gray clouds, and the sky, incredibly white and laden with moisture. IV tubes on the floor. A few porn DVDs spread on the floor in the front of the TV. Keys, mobile phone, two small plastic bags of marijuana. I smiled to the Chinese staff and closed the door while Kata emptied the packs in the toilet. The Chinese girls outside the door kept waiting, poker-faced and silent.

Katarina opened the drawer of Bo's night table. Inside, family pictures stacked up, face down. Life ran out of her and she turned white. Did I really want to be there? Did I really want to be part of that moment? But I had to, for her, and for my friend.

And I was, physically and emotionally, but in the background of these sad images I could see *the sea again, foaming with spray, rolling green and white and as far as you could see, all the way to that hazy horizon in the sun. And there was space, and there was beauty*

and there were no answers because there were no questions. The sea was, and that was all there was to it. The sea was.

"For love and regret go hand in hand in a world of changes swifter than the shifting of the clouds reflected in the mirror of the sea." *Joseph Conrad*, The Mirror of the Sea.

2 a.m. Hong Kong.

Katarina called me. The voice of terrible pain, of a broken heart, crying and screaming and panting in despair. It was all catching up with her. I went over to her room, which was only a few meters away. I hugged her while she cried. Her whole body was shaking heavily and I had to hold her tight. The flow of lights down in the city kept creeping slowly, no sign of letting up at all. Day and night, the rivers of metal flowed slowly in every metropolis on Earth. Planes cut the sky, satellites raced the stars, underground trains plunged in tunnels of darkness, cars crawled over the city, suspended like toys in a weightless universe. And with those rivers of metal flowed our unhappiness, downstream, like a broken house taken by the flood. No wonder Iorga said that eternity was born in the village. For some reason big cities breed unhappy people. I told myself maybe it was so because people had originally been born nomads and lived a free, peaceful nomadic life for centuries, until they got trapped inside the city walls. Fear, paranoia, violence, and depression followed. Then Prozac was invented, drugs flourished and escapism became chronic. Ecstasy, sex and rock'roll.

The light appeared in the east as a ghostly eye-brow first, arching at the horizon until it turned into a giant ivory gate, a gate to another day. Poetry and pain, love and regret. A deep feeling of sadness overwhelmed me. Those two people loved each other, yet they were trapped in different lives.

I sat in the hotel bar, high above the city, drinking rum and coke. Bo had been moved to the Adventist Hospital in Hong Kong and started the slow recovery process. The emotional wounds would last longer. Katarina was upstairs sleeping. I listened to Zen music and drank rum, watching the Pacific from the top floor of the building. Ships left a big phosphorescent "V" in their wake as they headed out to sea. What if I arrived here one day in my own sailboat, after crossing the Pacific? What would it feel like to see the lights of Hong Kong appear on the horizon after thousands of miles of empty ocean?

"Tomorrow I will fly back home," I suddenly told the bartender. He stopped from wiping the counter and smiled. The Chinese always smile when they're confused.

"I have a plan," I said.

Indian summer in Montreal. Fall colors against a clear September sky. I took a walk with my beautiful wife and told her I was leaving. For a while. She said she knew it. Somehow she always knows, even before I do.

"How did you know? I asked.

She laughed.

"You talk in your sleep, something about a walkabout."

I'm standing in front of this gigantic globe that revolves around its axis. It's transparent and a strong light glows in its core. I stand still, watching in awe: continents, islands, atolls passing by in front of my eyes, the Marquesas, Tahiti, Cook Islands, Fiji, Vanuatu, New Zealand, and Australia. It's all out there, waiting for me and my little vessel. A world of my own. I could almost touch it.

I sat in meetings all day without saying a word...looking moronic catatonic, and in my eyes a blue sea was rolling wave after wave of infinite power. I kept my usual poker face but if you came closer and looked me deeply in the eyes you'd see *a world of water vapors and rainbows, of killer whales darting out of the ocean, turning in mid-air and landing hard on one side with a big splash. You would see Canada geese gliding south along the Pacific shores or the stork flying in the silence of the dunes of the Namib Desert. You may see the Arctic fox digging her catch in the snow and the narwhals in a sword fight. You may even get a glimpse of the Japanese swans flapping their white wings over green fields of rice where straw hats look down in the water only to see their own reflection.*

I belong to no one. I belong to the great space inside and out. I fear nothing. I am alive.

"So what is your estimate for the 2006 efficiency gains for our product line?"

The question came like the loud morning buzzer from the bedside clock. I wanted to snooze it, turn around, embrace my pillow and go back to my dream.

"Sir?"

Then the question came again.

"Do you want me to make up the figures or would you rather do it yourself?"

"You go ahead," I said, thinking "I need to drink water. Why is my mouth so dry?"

I heard the flute echo in the valleys, and the axe resounding from the forest as it struck the tall fir. That was so many lives ago. Snow crackling under frozen boots on that path across the mountains of my childhood, in that forgotten country in Eastern Europe. Summers rafting on the river, the swish of an arrow across a cloudless sky. Eating cherries from the top of a tree, the sweet ones burned by the August sun, dark red and juicy.

Free children in a forgotten world. Post-war children, innocent and ignorant, as children should be. The trenches were covered in

yellow wild flowers and apart from the occasional rusty Russian bomb shell, no visible sign of a world war. That was just after the Communists took over, but I was too young to be bothered. Only later on did I end up on their blacklists, and eventually in a coalmine as a young man. Political prisoner, fugitive, asylum seeker in Sweden, and now a senior executive for a telecom giant in Canada. One hell of a trip.

"I'm a time spastic," I thought. "This present is not now. I am not I. They are not they…"

I looked around the room. People shifted in their chairs uncomfortably, mouths were moving, someone was showing something on the screen, but there was no sound. There was just this a-temporal silence, a silence I had longed for for many years. It was the silence of the mind.

Then I remembered the monk in his stone house up in the mountains and the smell of freshly-made candles burning on the ledge of his window. I remembered how I bowed before a man for the first time ever, just like that, out of an overwhelming feeling of respect for his renunciation of all that is worldly.

Winter day in Amsterdam.

Gray clouds and black rain. . The North Sea looked ominous and inviting from the plane, foaming in the harsh winter winds, waves smashing over the bow of ships coming to load and unload oil in Amsterdam or Rotterdam. Eerie flames from the oil platforms of the North Sea gave the scene a surreal feel, of a bleak and sooty future. I realized then that there was no way western civilization as we know it would survive for long. We backed ourselves into a corner and the final crash was imminent. Had a vision of stocks tumbling, panic, world depression, resource crisis, extremism, violence, more poverty. We screwed up and it would be generations, sacrificial generations, before the next upturn.

KLM flight 716 touched down at Schiphol. I headed for the business lounge where I was to get my whisky and my espresso while my laptop connected to the wireless network. Next flight,

Arlanda, Stockholm in 2 hours.Watched the news on BBC: North Korea went ahead with their first nuclear test. One million soldiers await orders to burn the world.

Iraq, Afghanistan, Somalia, Zimbabwe. Did we live on the same planet?

"Pass world!: I am the dreamer
that remains;
The man clear cut
against the last horizon."
Roy Campbell

Stockholm.

Management meetings, a gathering of vultures.

I gained a couple of pounds as usual, after all the expensive and extensive executive meals. I slept an impressive six hours in four days and I felt drained. Jet lag side-effects seemed to get worse each time. I thought I would like to travel in such a way that jet lag would never be felt, say at five knots with a breeze filling the sails from behind, slowly advancing across meridians, so your soul could keep up with the surroundings and with your own self.

Two important phone calls. The first one, from my wife, saying that she found the boat for me, a Contessa 32, perfect vehicle for my escape into the void, the shuttle to the other side. "We could go see it this weekend, after you arrive from Stockholm, if you like," she said.

Then Sebastian, my brother, called me at the office and said: "why don't we go to Vanuatu together?" He had read an article in *National Geographic* about a remote tribe on Espiritu Santo that had never seen a white man.

"Sounds interesting, my kind of people, you know," he said, "Let's check it out."

Anyway, why not, I said. I only had to quit my job and go. The white envelope was still on my desk and I was looking at it while pondering my brother's proposal.

I sent Bo an e-mail telling him I was going to resign and set myself free. Perhaps I should mention that Bo was now the head of an R&D center in Spain. He was back with the family and doing great. In fact, he drove a brand new BMW on the Spanish Riviera, lived in a beautiful art deco apartment in the heart of Madrid and would spend long evenings strolling the narrow streets of Spanish history watching a beautiful world go by on the sweet sound of guitar strings.

You had to be grateful that humans are unable to remember pain, and grateful for time, the healer of all wounds. Maybe we are the only creatures trying to bring order to chaos and understand while in reality there are only accidents and acts of God. Like electrons colliding randomly, so do we collide with each other in our lives, affecting each other for a nanosecond before taking on another erratic course through Universe. Accidents. Collisions. We help each other, we kill each other, we love each other, all a matter of accident. Is it possible? Passengers on an underground train, sharing the same route for a while, before some get off, while others continue. There are many trains, all going on different routes. Endless possibilities, yet you can only board one train at a time.

Did you take the blue line?

I visualized taking on the world, crossing the latitudes of silence where only angels and albatrosses reside. As I stood in the companionway alone, I heard the wind playing in the rigging, like a deep cello, vibrating with expectation. And I felt the waves splashing against her topsides and I quickly reached for the teak handholds. I heard the ocean and the wind and I saw the glassy eye of the albatross fixed on me and my little vessel. He's been gliding for hours on a parallel course, his gray-white head turned towards us, watching, observing, and almost saying: "Are you sure you're strong enough to make it here?"

...this soul hath been
Alone on a wide, wide sea;
So lonely 'twas, that God himself
Scarce seemed there to be.

There was a voyage ahead of me and it already started inside my imagination. This would not be a test of courage only; it would be a test of patience. I needed to pace myself to make it to the start line. No one else was in this with me from this point on. I was alone. In a way, I had died in my old life and emerged through a curtain of time to the other side. A world of my own. Alone with God and the sea. I was going out there to find the love of mankind once more, a love that had been lost in my previous life.

And if I shall die out there, I shall die at peace with the world, with myself and with all whom I met in my journey through life. The pain has been and will never be again, it's in the distant past and cannot be remembered any longer. I have known love, I have known passion, I have traveled the world, I have been poor, I have been rich, I succeeded and I failed. I have laughed and I have cried, I have known joy and sorrow. I have been human.

"Remember this dream," I told myself. "This dream is more alive inside you than anything else you ever experienced. Don't let go. Hang onto it for as long as you can. Remember this voyage. The sea is important."

A dark and stormy night. I couldn't sleep so I went outside for some fresh air. A cold wind was blowing hard from the southwest. I tried to imagine what it would be like to be on the boat out there on the North Atlantic.

Was it an insane idea to set out on such a long and arduous voyage? You'd have to know me a little better to be able to answer that. You'd have to understand where I come from and how I got here. I'll take you on an inter-continental trip that covers half

of this planet; I'll take you back in time, into another world, unknown and strange to you. Get the globe spinning in front of your eyes, and then put your finger a little to the right from Rome, over a little place called Romania. Then follow the rugged spine of the Carpathian Range north and stop there in the mountains in a small village not far from the border with Ukraine. Let's call it V. Get a little closer and you'll see the beautiful fir trees standing high over the river, offering cool shadow to the thirsty deer and clear water for the trout to play upstream. See the puffy cumulus clouds reflected in the water and the eagles circling high in the sky? That's where my brother Sebastian and I grew up as kids. It's the seventies in the west, the flower power is on, Woodstock just happened, hippies and Vietnam and love children are in the making.

The world was divided now, more so than ever before in the history of Mankind. The story goes that Stalin grabbed the stump of a pencil and drew the line across the map, the line that would divide the world for centuries.

The Communists were ruling over the East, from Berlin to Kamchatka on the other side of Alaska, in the Bering Strait. Almost half the surface of the globe is now being ruled by Utopia. The other half enjoys the sins of Capitalism, with its psychopathic corporations, over-consumption, overflow, and over-exploitation. Greed is the driving engine. At the opposite spectrum there was another Utopia, the *All You Need Is Love* movement of the hippies.

This is the Brave New World of my childhood. But I knew none of that. We had other priorities and our world was different. My brother and I were more concerned with finding the right peanut tree to build good bows and the right (straight and long) reed for our arrows. We were more preoccupied with exploring deep caves in the mountains, fishing, flying kites and riding wild horses through waist deep grass on the plateaus of the Carpathian Ridge.

The stories we read as children, Jules Verne, Joshua Slocum, Moitessier, stimulated my imagination to such a degree that at the age of fifteen, my brother and I built a raft and sailed it down the Moldau River for about a hundred yards before it sank. Undeterred, we tried a second time with planks of wood stolen at night from a local furniture factory, and it worked for about a mile, until the current smashed us against submerged rocks and we had to swim to shore. It was then we first realized the importance of having a steering device or, plainly speaking, a rudder.

Everything and everyone needs a rudder to steer by. Life, people, even the Universe needs a rudder to steer by. That's how you find direction in life. We need sails in life to reach our goals, and we need wind to sail. We need a rudder to steer by and of course we need an anchor to keep us grounded during stormy times. Some people are the sails in your life and others represent your anchor so you don't drift away. But sometimes it's good to be lost, to drift wherever the currents take you, to let life happen unhindered.

I grew up as a landlubber, and remained so, in the family tradition, for another two decades. We grew up like Mowglis for a while, small savages coming home after dark each night, hungry, filthy and filled with excitement after the adventures of the day. Animals, bizarre characters, strange places, dangers, surprises, everything was discussed under the sheets, watching the moonlight and the stars through open windows.

I remember climbing far up the barren slopes of the mountains, meeting the shepherds, living with them for days on end. I remember the wheels of cheese resting on wooden poles inside their shacks, each waxed surface shining yellow in the light of a pale candle, the corn cakes boiling like lava in huge pots over fires, the broad-shouldered shepherds and their dogs' bear-scarred faces. I remember the evening fire reflected in the pupils of those

silent, thoughtful men, the lonely shepherds, the people closest to the land, to truth, and maybe to God.

There's an image that pops up in my mind once in a while, that of a reed arrow piercing the clear September sky with a *swish*, its silver tip shining in the sunlight. That's how I can best describe my childhood: the gift of complete freedom, and a sort of live and let live existence without any specific target or goal, just living for the sake of life.

By times I can smell the strong mountain air brought down the valleys; I can still feel the cold rocks shining bright a foot under the water, polished over thousands of years by streams racing down the valleys and into the river. The white spruces, heavy with snow, and the silence broken by the rhythmic and echoing strike of an axe, those are the images and sounds that define my childhood.

At school, the wise words of Socrates and Aristotle were read to the youth of the village with the same pathos as to the students at Eton, and the history of the world stirred the imaginations of many kids during the long and cold winter months. We had no game-boys, no computer games and no entertainment arcades -- we didn't dream of the possibility -- but we had a good library with a great open fire and a librarian with big tits and overwhelming motherly love to keep us warm and happy.

The trouble started when we reached the teens. Our parents were teachers at the local school, history and philosophy. I firmly believe it was the charts and maps hanging on our walls at home and at school that are the reason for our troubles. We already had the Restless Gene, known in the family as RG, from our parents who moved seventeen times during our childhood, but now we really wanted to see all those places we used to travel to during long, cold, dark winters, when Dad would lift us on his knees, put his index finger on the map and take us on a voyage of discovery to the remote corners of the world. Now we wanted the real thing, we wanted to get on a train and go, we wanted to keep the windows down and watch the world pass by in front of

our eyes. We wanted the world to reveal itself to us, beyond the symbolic contours of a map. But the contour of Romania was keeping us prisoners inside the lines of its territory. We would never go beyond those lines, we were told. We were never going to see anything beyond the paper maps and the occasional old and yellow picture that accidentally landed in our hands. Nobody in our large family had ever seen a passport. We had heard of a distant relative that made it to Canada, and that was all.

"So stick to your books, Chris," I was told, "that's where you'll always find refuge for your thoughts and fuel for your dreams."

And so I dreamed.

I'd lie down in my room upstairs for hours, watching the flame lights from the fire dance across the white ceiling, getting into a trance, beaming myself somewhere else, where I was someone else, someone free on a discovery ship, say, on the deck of *Endurance* one morning with Sir Shackleton taking us to South Georgia, or climbing the North Ridge with Sir George Mallory, or flying over the Saharan Desert with Antoine de Saint-Exupery, or sitting in the lotus position on the deck of *Joshua*, chanting a Mantra with Moitessier.

These are the people that formed us and these were the stories that shaped the rest of our lives. No wonder later on I used to beam myself out of reality every time everyday life seemed insupportable.

When I became a teenager I started reading Jack London, Herman Melville, Francis Chichester, Tristan Jones and Joshua Slocum whose books opened the door to a bigger and more fascinating world, a world of great seafaring stories told by old salts and adventurers who reached remote destinations on their own keel. It was the thought of being able to reach another continent on my own little vessel, powered by the wind and navigating after the stars, which intrigued and fascinated me from the beginning. Then of course, there were the great travelers, Thoreau, Faulkner, Steinbeck, Hemingway, Graham Greene.

When Father opened the World Atlas in front of us and started a virtual voyage across continents, finger pinpointing the route along rugged and mysterious coasts and across mountains and oceans larger than our minds could grasp an itchy feeling of anticipation and excitement overwhelmed us, a feeling we would often seek in our world travels later on. Crossing those vast lands and waters printed on paper turned to suede by our eager fingers instilled in Seb and me a thirst for long voyages that has never been slaked. Curiosity never ceases to exist; the drive to find out what hides beyond the next horizon has addictive powers. Once one develops a taste for open spaces, for the freedom of choosing one's own path, one is caught forever. The nomadic life takes over, and the longer one is on the road, the harder it is to ever come back. A restlessness of the soul settles in, a longing for someplace else. This nomadic mindset turns us into outsiders, travellers passing by, temporal observers of a world in motion. We see life through the window of a bus speeding through yet another town.

How did I end up in an office 20 years later?

The nomadic life began early, and with it the first tangible demonstration that 'there's no place like home.' During my childhood we moved seventeen times; the last time we moved back to where we started, so the circle was complete.

First, we moved to a big industrial city, where Father had to seek employment as a worker in a steel factory. The reason was that as an intellectual during the glorious communist era one could not obtain an apartment from the government. Only the working class was endowed with that privilege. Father got a job at a factory and worked three shifts for over three years before an accident cut short his 'promising' career. A hot water pipe exploded, sending him through a second-floor window. He landed, and not softly, on a heap of industrial glass reinforced with steel webbing.

I remember a scene at night. I don't know if it was when they brought him home, or later, but I remember him lying naked in a white sheet, his skin red like a lobster shell, and Mother spreading

a yellow sulphurous cream all over him. He got forty stitches at the hospital and his burns were third degree.

Father was an incredible survivor. When he was a kid he used to walk or ski to school, thirty kilometres from my grandparents' home. He'd start at six in the morning, and by noon he was there. He'd catch up with the other kids who had arrived at the school early in the morning, and then at four in the afternoon he'd head back. One day his skis slid under a sheet of ice that broke both his legs. It happened way out in the fields, kilometres from the nearest village. He had almost frozen to death when my grandfather, who got word that he had not showed up for school, found him in a mound of frozen snow.

Another time he got stuck under a tree in the middle of the river. He had been under the water for five minutes when his older brother pulled him out.

Accidents would follow him throughout his life, including the 'big one' when he was thrown out of the train. My mother used to call those mishaps, 'the grand sweeps of Father's life.'

After the steel factory chapter, they turned into green, actually red-green, environmentalists. Everything that had the faintest touch of countryside style was proclaimed sacred. We moved to the country, of course, raised chickens, pigs and a cow. We had a couple of dogs and all food, even theirs, came from our own garden and stable. At Christmas, Father would open a pig's main artery and begin the millenary Greek Orthodox rituals of preparing the meat for the holidays. Blood sausages, blood pudding, roasted pigskin and a few other specialties inherited from the rather unpleasant Middle Ages, were not very popular with the kids. By then we had a little sister, Danielle, and she screamed at the sheer sight of the 'delicacies.'

The country life was exciting indeed for us kids, and we had a marvellous time hiding in the reeds by the main road with our slingshots ready, swimming in the lake in the heat of the

long summers, climbing old walnut trees, stealing grapes from vineyards, catching doves and hunting rabbits. We'd eat from the fields: tomatoes here, cucumbers there, walnuts and apples, grapes, plums and black berries. Then we'd come home, happy and tired as always, carrying dead animals on our naked, sunburnt shoulders, begging the parents to let us go to sleep without the ordeal of having to take a bath.

And sometimes, when we forgot to be back in time, especially when we went swimming, Grandma would come after us with a twig in her hand, whipping our wet backsides each time she caught up as we rushed home through the bush. Those were our 'country' days.

We moved again and again all over Moldavia, wherever they found a school in which to teach, or a good landscape for Father to paint. We learned to make friends fast, and not to have preconceived ideas about anyone, regardless of race, religion, or social class.

My wife and I drove to Midland, Ontario to see *Nerissa K.* She was so beautiful that as soon as we saw her we knew she was the one. We made an offer on the spot and a few hours later we were owners of a graceful yacht that would take us safely across thousands of miles of endless ocean. I decided to start keeping a log, recording the preparation process and the beginning of this voyage.

A few days later I handed in my resignation and within hours I could barely remember anything from that previous life. Only then did I realize how miserable I had been in that corporate role. But now I walked with a lightness about me that invigorated me, I felt as though I was twenty years younger, free and agile.

There were thousands of miles ahead of me, thousands of thoughts, thousands of silences, thousands of waves and long-forgotten memories. Being far from humanity would bring me closer to it than I'd ever been. The prophet said that the traveler

will appreciate the mountain much more from away than when he's climbing on it.

January 31, 2007

I am tired of the Waiting Room. If you're tired of waiting you should leave. I'm angry. It seems I've been waiting for something most of my life. Waiting for the winter to pass (as I write these words it's minus 20 degrees Celsius outside,) waiting for departure, waiting for visas and passports, waiting in airports, waiting to quit my job, waiting to get older so I have "more time." It's simply driving me insane all this waiting.

I need to be on the move. Travel calms me down and the harder the journey the more I lighten up. There is nothing more exciting than the night before a long voyage, the visualization of the path in time and space, the projection of the unknown, the encounters with people along the way and the expectation of a great story to tell at the end.

This constant longing to be somewhere else, remote, out of touch, forgotten and temporarily lost, is what travel is all about. Or should be.

Never mind, in a few weeks I'm off to the Islands of Love.

There's something out there that a landlubber will never experience or understand. Out there, where the horizon line is never interrupted, where the sun and the stars are the only constant albeit in perpetual motion as everything else, out there, far from land and humanity, there's a sense of space and freedom that tastes like a beginning, like a pre-natal memory. I feel I've been there before, before I was born and even before that.

I've started the final preparations. The boat will be loaded onto a flatbed truck on March 15, and I'll be on a plane to San Diego

two weeks later. Ahead of me is an eight-month voyage. You as a reader could skip to the last page to find out what happened in the end, but at the time I couldn't, and the unknown was overwhelming. A voyage means calculated risks, some adventure and an unpredictable outcome. What will be of this man and his little boat? Will he make it across the largest body of water on Earth? Will he navigate safely around the thousands of deadly coral reefs waiting to sink his boat in the middle of the tropical night? Will he see the New Zealand shore at the end of this passage? Or will he disappear at sea, never to be heard of again? Perhaps a whale will strike his boat, perhaps a storm will take it to the depths of the ocean, or perhaps he'll get sick and drift for months, starving to death, dying of thirst, or sheer madness.

Here I am, at the beginning of a great voyage. Exactly where I ought to be.

If you can dream--and not make dreams your master, If you can think--and not make thoughts your aim;
Rudyard Kipling, *If*

Here's a man and his mountain right in front of his eyes. He weighs up his chances, he knows there will be a price to be paid, and he's willing to pay it, hoping the mountain will be forgiving and not too harsh. And he says a short prayer before he sets out to meet his Fate.

"God, I'm going out there to see your beautiful world. Please be good to me."

Once he sets out to work, there's no turning back, no ifs and buts, no regrets. The dice are thrown. He's void of emotion, feelings or fear. He consists of nothing but will and determination. He understands that he means nothing in the great universe, that he's but a speck of humanity in a timeless space, a warm, living breath dissolving in an endless sky.

And, as many times in the past, the world opens its arms and welcomes the traveler, protecting him at night, and guiding him

during the day. It's that feeling of acceptance that the traveler seeks over and over again, of being one with the world, of being part of its movement and life. Then the Universe will conspire in his favor. And he succeeds.

I've never been happier. And I know, I just know, this will be the happiest year of my life.

March 6, 2007

Incredibly enough, almost a ton of gear and food supplies were loaded into the boat. I found an unlikely weather window between two snow storms and managed to do this critical job of transferring a basement full of stuff onto a 32-foot sailboat. My father helped me with all this. He stood by me those cold days, freezing in sub-zero temperatures, working with me to get the boat ready. This is what it's all about, sacrifice. Sacrifice and pain for a dream, for a goal, for this incredible and impossible mission.

In seven days the boat will be lifted onto a flatbed truck and moved to California. Then I'll fly to San Diego and get to work. If all goes well, in a few weeks I'm off to the big blue ocean Magellan called the Pacific.

Keep your fingers crossed.

I wish you all a productive, industrious and profitable life. I wish your stock goes up, your promotion happens, your lawn is free of bugs and you get a tax refund.

As for myself, I'll settle for the sunsets and the trade winds.

Every journey begins with a prayer. Some people say it out loud; others utter the words in their mind. I've never been very good at this but as the last of the San Diego skyline disappeared

behind the horizon I remembered Tania Aebi's short, yet moving prayer:

"God, I'm going out there to see your beautiful world. Please be good to me."

The beginning of a voyage at sea is always hard. Hard on the body, hard on the mind and hard on the heart as well. The tormenting goodbyes are still stirring inside when the first signs of seasickness make themselves visible. And ahead it's the unknown, the vast ocean with no land and no humanity in sight for thousands of miles.

It's hard to explain to people the amount of preparation involved in such a project. The endless lists of equipment, spare parts, medical supplies, food, water. I had to be completely self-reliant for up to one hundred days, just in case. If I had forgotten something, the next gas station would be four thousand miles away.

But I was well prepared. I trusted my boat and in all my years of sailing I never prepared a boat more thoroughly for a voyage as this one. I knew *Nerissa K* would not let me down. It's us, the people, which make the weakest link, not the boat. We are fragile, moody, and when the body takes a beating, the mind becomes either a savior or the worst enemy.

Flavio Castellani and Dino Martucci, my two Italian friends, joined me in San Diego for the long passage south. Three thousand miles of open ocean stretched ahead of us and butterflies were flying in our bellies as we set out of the harbor. It's ridiculous to think that such an undertaking does not bring worries and fear. It is the length of the passage and the isolation from any assistance that keeps people awake the night before departure. As it turned out we drove straight into a gale after departure and I knew this was just the beginning of the test to come. I've been in storms before and I wasn't at all worried, just miserable and seasick. The waves were 18-foot high (the size of a two-story building) and the wind was blowing 35 knots, gusting 40. Quite a change from the mild and sunny San Diego. But I thought it would last three days

and then we would glide silently over the great calm ocean called El Pacifico. But there's nothing pacific about this ocean except its name. Magellan fell for the first impression when he entered the Pacific from the stormy waters off Cape Horn. The first impression is usually wrong.

It was very cold, wet, cloudy and dark, day after day after day. At one point I thought we made a navigational error and we were headed for Alaska. Polartec hats, gloves, full storm gear on us, fleece middle-layers...off the coast of Mexico?

For twenty days we never saw the sun or the moon. Not one sunrise or one sunset. That's what drained us of energy. We had a cross swell from the northwest and the northeast and we could no longer use the autopilot or the wind vane so we had to steer now by hand 24/7. Day in and day out we were out there, in the cold darkness, sore and in pain, frozen stiff and covered in salt. And I clearly remember one day when I was exhausted and fed-up and thrown around in the cockpit like a sack of potatoes. The cloud cover was dark and menacing like a low ceiling over a ghost-ridden waste of water. I was exhausted. I was at the end of my rope.

And I closed my eyes and said:

"Ok Boss, what's next? What's the plan now? Give me a sign. Is this going to end up well or not because I might as well sink this boat myself right now."

And as I opened my eyes a crack appeared through the clouds and a cathedral of light rained down on us. The cone of light with its clear rays lit a patch of water about sixty feet wide and it turned the sea into the color of a bright silver plate. It was one of the most beautiful moments I had ever experienced. That's why they say there are no atheists at sea.

The sea takes you back in time, it is a curtain of water through which time and distance dissolve. Every night I felt I had every important person in my life with me in the cockpit, from my grandparents to my university mentors.

One night I remembered listening to the strange stories from the seven years my grandfather had spent as a prisoner of war in

a labour camp in Siberia. I remembered the vine-covered terrace and the sunlight penetrating the greenery and the grapes hanging heavy above our heads. There was a carafe of wine on the table and he'd put his legs up and his hands joined together on his Balloo belly. He'd start with a remark or two about the war and always end up hours later recollecting the moments of life and death, of short-lived joy and interminable suffering that he experienced in captivity.

He'd tell us how they survived temperatures of below 60 degrees Celsius, and how the Russians had sewn their trousers' pockets so that they would stand properly, in a military posture, in front of their superiors and not hide their frozen fingers inside the rugs they were wearing. He'd tell us about his love for the beautiful Russian girl who ran the herds of caribou across the frozen valleys of Siberia, and how they made love at 50 below, under piles of bearskins. How it was to eat horsemeat all year round, and how the piles of potatoes and cabbages were left out to freeze in the winter and how they'd split them open with an axe. How it'd take them two full days to dig a grave in the frozen ground, lighting a fire to melt the surface, then scratching the first layers of earth, then lighting the fire again, and so on. And how after the war he had to climb on the roof of a train to get back home, and how he survived several weeks on fruit from the trees along the railway and corn from the fields. I imagined him running after the train with his shirt full of apples and pears and cherries. When he returned home after seven years, his house was empty, the whole village was empty. Famine had forced the people to migrate south. That year the southerners saved hundreds of thousands of lives by taking these families into their homes, feeding them and caring for them. They had a hard life themselves, but whatever they had they shared with the refugees. Grandfather had to search half the country to find them and bring them back home.

Those were the stories he shared with us, and more than once I thought I noticed his teary eyes turning red and glowing with flashes from the past. More often than not the stories made him teary with humility and pain, and gratitude that God brought him back to his country, the only place he ever wanted to be buried in.

The sea, the sea. She always brought up things I never otherwise reflected upon… But what did I know? Here I was philosophizing about the wisdom of Fate; *Nerissa K* was ploughing the ocean and I was brooding over a life consisting merely of a series of arrivals and departures, of people won and lost, of small victories and lost battles, and of slices of happiness. Was I a replica of my grandfather? Did I live his life, with some minor changes, like a theatre set made of painted gypsum, altering the geography of the site while the story remains the same? Was my life a film that had been recorded previously, and played now for me again? Was I a prisoner of war myself, albeit a different kind of war?

But here I was now, sailing the Pacific.

One evening, as the night fell over our sea while we prepared dinner below, I scanned the horizon around us. I saw a large glow off the stern and announced that we had a cruise ship for company. The boys climbed the companionway ladder and stuck their head outside. It was a beautiful evening and we were becalmed only hundred and forty miles from the Equator. We waited a few minutes, watching intensely the rising object in the distance. It became larger and larger by the minute, a spectacular apparition on the lonely surface of the ocean. I frowned a little sensing that my friends are going to use this against their captain:

'That, Captain, is what we sailors call THE MOON!' said Dino.

'Bugger!' I exclaimed.

We laughed for a good half hour after that, watching the gigantic ball of orange light rising above the South Atlantic like

a Chinese lamp floating in space, bouncing like a balloon from star to star.

Orion's star-studded figure showed up in the east as well, armed with his sword and his shield, ready to fight.

Orion, from the Greek word 'Arion,' meaning 'warrior.' , son of the sea god, Poseidon, and a mortal woman, a demigod and a great hunter. When he angered the Olympian gods by saying that no creature on Earth could match his strength, a deadly scorpion was sent to kill the arrogant hunter by stinging his heel.

Artemis, Orion's lover, pleaded for mercy and the gods honoured the brave warrior by giving him a place among the stars where he could shine down in all his glory.

The deadly scorpion was placed on the other side of the heavens (forming the Scorpius constellation) so they would never meet again.

When Orion sets in the west, Scorpius rises in the east.

That's the story of our stellar guide in the sky. J.R.R Tolkien, in his famous *The Lord of the Rings*, speaks of Orion as Menelvagor, The Swordsman of the Sky, in the Third Age of Middle-earth.

Besides its three stars forming the sword, Orion shows three other brilliant celestial bodies that create the belt of the constellation. Alnitak, Alnilam, and Mintaka are between 800 and 1,400 light years away, and thousands of times more powerful than our own sun.

Betelgeuse and Bellatrix form the hunter's shoulders and Rigel and Saiph mark his knees.

The star in the middle of Orion's sword is in fact the Great Orion Nebula, a beautiful luminescent cosmic cloud in the shape of a blooming flower, one of the most spectacular nebulas visible on the planet.

'So you see, boys, we have our friends out here on the ocean, and they guide us and they entertain us with their stories from the beginning of time.'

We watched the sky for a while longer, then set the table in the cockpit, opened a bottle of wine and sat down, eating in silence under the stars.

THREE MEN IN A BOAT

Here's a day in the life of the Nerissa K crew and captain:

A typical day at sea…well, after sunrise there's a pot of coffee in the making, if the bowman is not too tired he makes some incredibly delicious pancakes topped with premium Canadian maple syrup. At about 10 a.m. we usually check the day average and total progress from the last waypoint the day before. We usually clock about 120 miles a day. Sometimes more, sometimes less.

At this point the guy that had the dogwatch goes to bed and the new watch takes over while the third guy is on stand-by, reading, listening to music, but most probably napping below in his bunk.

Let's say Flavio takes the watch. He steals my iPod, and goes behind the wheel. Minutes later I hear him digging deep inside a locker and I know he's after Digestive crackers. Then I hear the locker behind the stove: that's where the Nutella is stored. Then he goes back at the wheel quickly before I can hear the boat going off course and sails banging. I drift off to sleep while Flavio watches the birds and the ocean and steers southwest, towards the Marquesas. Dino is sleeping in his bunk with the orange ear plugs sticking out of his ears. His left leg bounces from left to right every time the boat lurches over the waves.

By midday I get up and join Fla in the cockpit. Dino comes up as well, more tired than when he went to bed. We want food, but say nothing until Flavio decides to make a tomato soup. Then

everybody's happy and upbeat. Except Dino, who can't take the acidity in the soup so he opens a can of corn and eats straight from it.

Flavio is off watch and I take over. The iPod is depleted by now and has no battery left. But he made an incredible soup so I say nothing. I plug the iPod in the charger and steer for two hours without music.

I settle in for the watch. I steer, I feel the boat, the wind, the blue ocean, and always, always, my eyes look far to the horizon. That is the most intense sense of freedom a man could experience. Trust me. An open horizon, a star to steer by, space, sky, wind and water.

Usually by dinner time the mood improves significantly. The conversations are flowing, the food smells great from the cabin, there's a shade of light dimming slowly in the west, and maybe there's a drop of rum to be enjoyed before sundown.

Now Dino takes over and so we continue the cycle until someone shouts, "Land!"

Sometimes I see the moon through the port portholes and then, seconds later from the starboard portholes. I scream at Dino and he's turning the wheel three times over. Sails are popping, the rigging is trembling, the mast is shaking all the way to its base. We've all done it before.

I lean over so I can look at him. He shrugs and shouts back:

"What do you want me to do? 210, just as you said."

Then I see him fumbling with his mp3. His mp3 and my headset.

During the night there are several sail changes, which require effort and energy. Sometimes we're caught in squalls, sometimes the wind dies. Pole out, pole in. Thunderstorms and lightning.

Then blue skies and stars again. The circle of life on the ocean.

Three men in a boat.

Cooking is a major feat out on the ocean. It's easier to cook inside a space shuttle than on a boat. The G-forces on a boat being pressed hard by wind and waves should not be underestimated. First you need to make sure that all ingredients stay where you want them to and not fly around. That sounds great but it very quickly becomes evident that it is impossible to achieve. Second, you need to have the stomach to be down below and do all that. Third, you need to have a high degree of patience as the boat does not listen to you when you ask her to stand still for a moment.

Flavio was a great astronaut cook. His perseverance and determination to get a decent meal three times a day really impressed me. But many a times he was slung like a doll across the companionway and slammed against the navigation table. On this leg, Flavio took the prize with honors.

Of course, food was found everywhere. I found different types of cooked pasta under my bed, in my boots, and, believe it or not, even up in the mast. I have a gimbaled stove and that helps a great deal but sometimes the shock of a boat crashing into a wave or being knocked over by a roller is so great that gravity doesn't work anymore.

Personally, although I am by nature a very meditative person who can sit and watch the sky from the cockpit for days on end, I have educated myself to keep a religiously clean galley, and the general cleanliness of my boat is almost military. It keeps me busy,

and it makes me feel good about it. In fact, it keeps me sane and disciplined in a very primitive environment.

Other than that, I do not need any links to civilization to feel good.

I listen to my classic music, I read books, I write and I think, and therefore, as my friend Descartes pointed out, I exist. The most difficult balance to find out there is between the technical side of traveling the world in a little boat, the equipment breakdowns, the maintenance and repair situations, and the spiritual side of it, the higher purpose, the inner journey that we experience. There are far better ways to travel than by a small sailing boat. It is uncomfortable, slow, can even be dangerous at times, and it requires thousands of hours of effort before, during and after the journey. Since that sort of lifestyle can be barely justified through reason, there must be something else that lures people to the sea; there must be a bigger picture out there, a longing for something fundamental to our human existence, a longing for freedom.

Physically and mentally it is very draining, this long-distance sailing business. Imagine a twenty-four hour existence in constant motion. Imagine your room tilted thirty degrees and bouncing every second in a different direction, slamming you against the walls if you don't hang on to something. Imagine working, sleeping, eating like that in a space the size of a Volkswagen minibus. Imagine working in those conditions with precision instruments on a chart where every inch of error equals one hundred miles of ocean. Think about lighting the propane tank with a cigarette lighter while you're being thrown around by erratic waves, the gas button open and you flying through the cabin with an open flame in your hand. Then you go to sleep, you want to turn it all off, you want the motion to stop, no more roller coaster rides, it was fun but now it's enough, please keep this boat still. But the motion never ceases, the movement never stops, because life is like that, life means constant movement and constant change. And the ocean is alive.

Then imagine that a sail halyard got stuck at the masthead, forty feet up in the air. You have to climb up there, but you want that stick to be still. Yet the higher you go the more wild and violent the motion gets, like being at the end of a whip, you swing up there from one side to the other, you can barely hang on with both hands but you have to work and get that halyard undone or you'll never sail to your destination. You'll bob up and down there forever. You'll never get home.

Then night comes and you get in your sleeping bag and it's nine degrees Celsius inside and you try to sleep but you hear the sound of the ocean next to your face and it's only a quarter inch of fiberglass that separates you from that big ocean. And beneath there are fifteen thousand feet of water and the closest land is actually the bottom of the sea, because you haven't seen land in days and you know it's hundreds or thousands of miles away. Then when you're finally tired enough to sleep, someone shakes your shoulder and tells you it's your watch. And it's 2 a.m. and you're dizzy and sleepy and your body is stiff, your mind not clear, but you have to go up there, where the wind whips your face 'til your eyes fill with tears, yes you have to, otherwise your little boat might collide with a ship. And it would all be over. Then you'd get your sleep, the long sleep.

Romantic? You bet. Despite all this we go out there and do it. Why?

Moitessier said we do it in order to 'save our souls.'

Crossing the Equator is always a big moment for a sailor and we celebrated onboard according to old sea-faring tradition. And from that point on we had the sun with us everyday. And the gentle trade winds were steady and warm, and the Southern Cross guided us in the subequatorial night across to the happy isles of the southern hemisphere. The moon laid a path of light for us every night and once in a while a whale would blow air just next to the boat. We had made it through the iron curtain. We were

over to the good side. We broke all records during that week. We sailed the remaining eight hundred miles in only five days. And then, "LAND!"

The majestic green peaks of Nuku Hiva appeared early in the morning and as we approached the large island we were shocked by the smell of humid earth, sweet flowers and the sight of countless birds, out chasing for breakfast on the calm ocean. As we passed the Sentinel of the East, entering Taiohae Bay, a pod of large dolphins welcomed us to the Marquesas.

We dropped the anchor and sat down, listening to the sounds of human activity from the nearby village. Children chattering happily as they entered the schoolyard, stores opening, people buying fresh bread from the baker's, scooters buzzing around, a church ringing its bells across the lush valley scattered with banana trees and pineapple plantations. We had finally arrived in paradise!

One story my crew like to tell every cruiser they meet is the story of the captain and the flying fish. The captain is snoring in his bunk when he suddenly jumps up, runs for the companionway reaching desperately with both hands in his underwear and screaming for his life. The crew watches all this with a mixture of awe and horror. The Captain looks wild-eyed, his nose is burnt and he experiences another bad hair week. On top of that, there's something he's looking for in his underwear.

It turns out that a flying fish had the misfortune of landing straight into the captain's underwear as he was asleep. Both the captain and the flying fish were in agreement that the latter should not linger too long in this emergency landing spot, but the problem was coordinating the exit strategy.

Anyway, the crew needed a story to demystify the captain's spotless reputation. Now they have it.

The good thing about sailing with Italians is that you'll eat well no matter how rough the conditions on the ocean are. The pastas that we had onboard were of the highest standard and with

the best ingredients a captain can wish for. The bad thing is that every time we had to reef we had to first remove the Bertolli Extra Virgin Olive Oil from the mainsheet pocket, the basil leaves from the halyard pocket and the Pomi tomato sauce next to the jib sheet. The onions and the garlic were always close by as well.

Nuku Hiva is the first pearl of the Pacific as one approaches French Polynesia. The island displays several micro-climates, from the tropical to the alpine and the views are worthy of a National Geographic footage. We rented a car and had a great safari around the island snapping pictures and filming the dramatic landscape. The driving there is difficult because of the dirty road winding precariously above the ocean but again, the sights are well worth the effort.

On a round the world tour like this one has the privilege to meet some interesting people. There was the father and daughter team on *Sora,* finally in French Polynesia after a six month refit in Panama due to a devastating lightning strike. Captain Terry Kreitzberg, former airline pilot, and 1st mate (daughter) Cassie and my crew had an interesting debate on the Faraday's Cage principle while sipping a bottle of wine on Cassie's birthday. There was Neil Graff, the single-hander from Vancouver who suddenly quit his job and left Canada in a Cal 2-29 three years ago. The intention was only to join the Baja Ha-Ha Race with a friend but now, well, let's sail around the world, what the heck. It's always impressive to see the resourcefulness and ingenuity of single-handers and Neil was a living example of that: self-reliant, reliable, independent.

There was the Australian couple who bought a brand new Jeanneau 49 in France and was returning to the Down Under. It made me think of Paul Theroux's observation: "And there were Australians, but wherever you see Australians in the world, they always seem to be on their way home."

And they were returning pretty fast I may add, at a speed of 275 miles a day or sometimes eighteen knots sustained over several days. They did have to cut the spinnaker halyard during a

black squall that threatened to bring the rig down but managed to retrieve it. He was all excited as he told us the stories. She was a bit pale. Maybe it was all that speed.

Then there was the Turkish-flagged Bristol Channel Cutter skippered by self-made man Ozkan Gulkaynak. Single-hander, independent thinker, idealist, self-learned designer and boat-builder, Ozkan had built his own boat over a period of five years. He got the plans for the Bristol Channel Cutter on A4 papers and set out to even "improve" the underbody of the boat to make it faster. He had tried to hire professionals but was "not happy with the quality" so he ordered a few boxes of books and learned to do it all by himself. Just like that. He even cast his own portholes. And the result was impressive. The boat looked beautiful and according to Neil, who for a while sailed in tandem with Ozkan, it was impossible to keep up with him. As soon as he set his sails he was off beyond the horizon. When I had lunch with him in Papeete he revealed the fact that he also built the best-looking Tom Thumb out there. And on this voyage he decided to have no electronic navigation onboard, just a sextant and the tables. "It's a very romantic voyage for me," he said.

Also, in Papeete we met a French couple sailing a 40-foot steel Caroff, personal friends of famous Bernard Moitessier. They had been in French Polynesia for four years and when I asked him when he left France he could not remember.

"Many, many years ago," he said. Unfortunately I never got their names but I'm sure we'll bump into each other again.

And of course Matti, the Finish sailor who sailed from Ecuador with only half the rudder. And he wanted to continue until on to New Zealand but the Gendarmes had not allowed him to leave French Polynesia as the cyclone season started. He had been in Papeete for eight months, now more a local figure than a nomadic cruiser. Matti, at nearly eighty, was our warm and friendly neighbor at Le Quai and great help with directions and local knowledge.

Rangiroa was our only stop in the Tuamotus this time around because the crew was on a somewhat limited time schedule. We anchored in front of Kia Ora Resort and marveled at the turquoise lagoon fringed by lush tropical vegetation and rows of palms exploding with all shades of green and yellow. We pumped the dinghy and rushed to the bar at Kia Ora for a sunset Martini. Unfortunately the one we named Adolf was on shift that night. As soon as we tied the dinghy to their dock and walked towards the thatch-roofed bar, Adolf came running out in a panic.

"'Scuse me, 'scuse me, do you have a reservation?"

Negative.

"Are you guests here at the resort?"

Negative.

"We've come here by boat," I said.

His face made a grimace as though we had an incurable disease.

"Ouch, cruisers, I see. Well, we have a dress code here for the evening and I'm afraid I can't let you in. But if you go back to the boat and change into something with a collar it should be fine."

He winked at us as though he was actually doing us a favor and closing his eyes to this contravention.

We did go back and after digging out some wrinkled shirts we went back in.

Flavio was upset.

"Dress codes. Listen to this guy… Giorgio Armani goes around in a worn-out T-shirt and holed jeans and he wants a dress code on a bloody strip of sand in the middle of the Pacific! I hate dress codes."

Anyway we had our drinks and…planned our revenge. Being accompanied by two Italians it was the only way. The next day Dino took Adolf aside and paid him back with same coin.

"Listen," he said, "the captain is a travel writer. He goes around the world and writes about his experience in different places. You, know, like here, at Kia Ora, things have to go perfectly because he's a difficult, grumpy old man even when things go right but if

you manage to upset him in any way he'll crucify you in all the big international magazines. And you wouldn't want your name associated with any bad service, right?"

Dino said that as he was speaking, Adolf's ears grew larger and larger.

"Sir," he said, "I assure you that we will spare no effort in making the Captain's stay here as pleasant as possible. Can we offer you a complimentary bottle of our best wine?"

There we go. Four days in paradise. Best service in the world. Kia Ora, I highly recommend it. And I think us cruisers may have obtained a higher cast than what we had initially been given.

Forty miles out of Tahiti I saw the lights of Papeete. First I thought it was a cruise ship but after the last embarrassing "sighting" I took my time before I woke up Dino for a second opinion. Well, my friend was blind with sleep and exhaustion and it only made the whole thing more confusing. But I kept looking at those lights until I saw the planes landing at the airport.

I hove two at three in the morning and awaited daylight. I lied down in the cockpit, watching the stars and the sliver of moon with a halo around. It felt good to be there. Another plane flew above and it made me think of my first love, Christine. I fell in love with her when I was fifteen, we were both fifteen.

"When he opened his eyes that morning he knew that fall was there. He felt it in the air, sharp and thin, and in the clearness of the sky and in the whiteness of the sunlight. It was there. He could feel it, but he couldn't explain it.

He jumped from the bed and opened the door to the balcony. The village lay still under the September sky and the mountains guarded the valley with silent pride. Once in a while, a rhythmical strike resounded from the woods, an axe biting into a spruce. Sleepy cows

walked uphill in Indian file, joined at times by flocks of geese with
their haughty walk and affected manners.

The first day of fall had reached the mountains of Moldavia.
Leafy trees turned into nameless colours, as though a bucket of paint
had been thrown over the secular forest. Only the spruce and pine
trees remained green and sharp, scratching the deep blue sky lit by a
white sun.

He changed and went downstairs. His father's paintings hung on
the wall along the oak staircase that led to the bottom floor.

They told the history of the family in a personal way, landscapes
that they identified with, dark memories and happy moments in
their lives immortalized on canvas through symbols: a white horse
running in the dark, a broken church bell washed by foamy waves,
an innocent eye, a hand.

He went out and washed his face at the pump, his skin benumbed
at the contact with the cold water that came from a deep well up in
the mountains.

His mother sat under the old walnut tree, sewing.

'Morning Mom,' he said.

'Good morning, honey,' she said, surprised she hadn't heard him.
She stood up and walked slowly towards him. She kissed him on the
forehead and caressed his black, curly hair.

She watched him in silence, her eyes smiling, mild and clear blue.
Her hair had turned white since her husband had the accident. She
had spoken few words afterwards and preferred to be alone in serene
solitude.

She touched his cheek and said, 'I'll fix your breakfast in a
minute.'

She walked slowly in, her head up, her hands slightly apart. He
had never seen her cry or heard her complain.

A big stork flew across the red tile roof, striking the air with its
wide, silver wings. Christian watched its route towards the high sky,
where it joined a V-shaped formation for the long journey across the
seas.

He went out again and kissed his mother.
'I'm going to the holm,' he said.
'Don't forget about lunch, Christian.'
He jumped over the wooden fence and followed the village lane, carrying the guitar on his shoulder. After a while he took a narrow path flanked by burnt Indian corn. He jumped over another fence, walked across the railway and then climbed on the dyke.

The stream resounded clear in the forest, on the other bank. Enormous spruces hung threateningly above the water, their roots clenched firmly on the shining and ever-resisting granite rocks, like long, white fingers.

He used to dream about building a raft and descending on the Moldau River, and all the way into the Black Sea. His father had promised to help. The sea was IMPORTANT, his father had told him. 'Like the mountains,' he said, 'the sea will test you against yourself.'

He sat on the dyke and picked the strings of the guitar. Up in the sky a goshawk rotated with effortless patience. As he lowered his eyes to the ground, Christian saw two human shadows on the other side of the stream. He took his guitar and jumped into a reed bush.

She was with her uncle. He was fishing trout and she sat on the bank, in the shade, reading. The man's hat reminded him of his father's. His father would stand just like that man, in waist-deep water, tall and proud, elegantly spinning the line above his head.

Christian let the sun be reflected in the guitar, directing the light towards the girl. He signalled a couple of times until she raised her eyes from the book. She made a quick gesture with the hand, that she had understood and wanted him to stop. He didn't stop.
Christine hoped that her uncle hadn't noticed.

After a while, he turned towards her.

'Why is your boyfriend so shy?' he asked.

She bit her lip and looked down on the pages of her book.

'He's not my boyfriend.'

Her uncle smiled.

'Why doesn't he come here to join us?'

After a moment of silence he smiled again under the brim of his hat and said:

'Come on, jump on my back, I'll take you over to the other side.'

She climbed on his strong, wide back and held onto his tanned neck.

'Don't embarrass him, okay?' she shouted in the middle of the torrent.

'I promise I won't,' he said laughing.

He pretended to lose his balance in the rapid stream and she screamed.

Christian watched them from the other side. His face turned scarlet and his heart pounded faster. He felt ludicrous, crouching down in that reed bush like a terrified hare.

The man left the girl on a rock and returned.

'Just don't be late,' he shouted as Christine waved from the dyke.

They walked on the railway sleepers. There was a smell of fuel oil and girdled metal. The heat made the air boil above the tracks.

She jumped on the track and walked on it with her hands up, balancing her body, using the book as one of those fans they used at the circus. She wore a red dress that whirled up from time to time, uncovering a pair of tanned legs.

'The authorities gave me the visa,' she said unexpectedly.

'What?'

'I will be reunited with my parents. In a month or so. The police finally gave in to the International Red Cross. I'm going to move to Germany.'

Many Germans remained on Romanian territory after the war. Some families tried to return to their homeland after the communists took over, but the regime used every method to hinder them.

She spoke fast, without any intonation, as though she wanted to get it over with as quickly as possible. He remained silent. That fall was not going to be like any other.

'Are you happy to go?' he asked.

'I don't know . . .'

They walked past a timber factory and it smelled of resin and fresh sawdust.

He didn't want to show any sadness. Not then, anyway. Later, when he'd be alone.

She jumped back on the sleepers and took his hand. She then kissed him on the lips and caressed the black curls hanging on his forehead.

He sighed.

'I know what we'll do,' she said. 'We'll take a love pledge and swear to love each other for the rest of our lives.'

A train whistled somewhere in the valley. The echo passed above their heads and further on towards the blue peaks bathed in a milky light.

'Where?' he asked.

She remained thoughtful for a moment and shrugged.

'I don't know. I haven't thought about it ... but do you want to do it, Christian?'

'Yes.'

He took her palm in his and put it on his cheek. She smiled and caressed him.

He knew where.

'I know where,' he said.

'Where?'

He pointed at one of the blue, mysterious peaks.

'By the sea, at Fisherman's Cove. At midnight.'

Her smile disappeared.

'Fisherman's Cove!' she cried. 'That's so far away, Christian!'

'I'm going to the sea,' he replied. 'Now.'

They sank into silence. The train appeared at the curve, heavy, steamy, its black engine slowly pulling the rusty wagons loaded with timber. A royal red eagle had been painted on the front, a remnant from a kingdom lost in the dusty pages of the past.

'Are you coming or not?' he asked.

She watched the train coming closer and closer.

'Christian, the train...'

'... Are you coming or not?'

The engine driver blew the horn again and waved hysterically.

'Christian, please!'

Her eyes were fixed on the monstrous machine that puffed its way ahead. The whistle gave out a deafening scream. Her lips were moving, but he couldn't hear her words. Every second seemed to have dilated into another time dimension. Their gestures seemed late, as filmed in slow motion, their words distorted, remote.

He grabbed her wrist and pulled her into the ditch. The engine passed, its brakes grinding an unbearable metallic music, its driver shaking his fist.

Her arms were folded around his neck, her head deeply sunk at his chest. She cried. He watched his guitar, lying untouched under the wagons that passed. Her Yevtuschenko book of poems was there, too, its pages fluttering in the draught.

They got up and jumped on the last wagon, first the boy, and then the girl, clinging to his arm. They kissed and held each other as the last houses of the village passed by.

The train disappeared in the valley, leaving a trace of thick, black smoke behind. The trace disappeared too, after a while, as the southbound train trudged on beyond the blue peaks of the mountains.

Hours later, a black-blue sky sank the village in its nocturnal numbness. Gas lamps were lit in the windows and smoke came out

*of the chimneys. The air was still and it smelled of hay and baked
potatoes and apples. The river seemed to resound louder at night,
like a permanent breath that fanned the woods, the village, and
the glowing stars. And the river ran fast and furious, through the
mountain, down the green valleys of Moldavia, across the wide plains
of the south, and into the sea.*

A very memorable night that one, outside of Tahiti. I had been
transported back into such a vivid dream of the past, somewhere
in my other life, far away on the other side of the earth.

The reason I came to think of her that night was because years
later I heard she had become a flight attendant for Lufthansa
and every time I saw an airplane I wondered if she was up there,
serving champagne in the business class. And I thought, if she
were in one of those planes, what would she say if she were told
that thirty thousand feet below, in the dark, there was a man lying
on his back in the cockpit of his boat, thinking about her.

She married a pilot and had two children. That's all I know
of her after twenty five years.

Anyway, I used to dream of the sea when I was a child. And
here I was now, crossing the largest ocean on earth in a little vessel
of my own, in a world of my own.

Papeete was as expected. Noisy, crime-ridden and ridiculously
expensive. But the women there are out of this world. The French
influence combined with the famous beauty of the vahine makes
this the hardest test of the entire voyage. It made me think of
Cohen's lyrics:

"There's perfume burning in the air,
Bits of beauty everywhere
Shrapnel flying
Soldier hit the dirt."

I called my wife from one of the phone booths close to the famous Le Quai and asked her to come to Tahiti earlier.

"My immune system is low, darling," I said. "Better show up here fast. Until then I walk around with a Bible in my hand, trying to stay on the righteous path."

She laughed. "Use beauty as inspiration for your writing," she said.

I'm unable to be indifferent to beauty. Beauty, whether in art or people, demands a reaction.

Hence this story.

With the crew gone and unable to face the temptations of Papeete one more day I sailed to Moorea with Dino and after his departure I secluded myself like a monk in Opunohu Bay. I had groceries for 2 weeks, enough rum for Mr. Christian and crew and enough stories to write about until late at night. The iPod was loaded (Mozart tonight) and the laptop was on. I was surrounded by sheer cliffs, palm trees and emerald green water. The sky was a cathedral of red light in the west and there was a faint smell of sweet flowers and humid earth. Such was life in paradise.

Humor and sarcasm aside, there was a great sense of achievement for all of us that made the long passage from North America to French Polynesia. The passage was hard in all aspects, physically, mentally and emotionally, and I as a captain was very grateful that we had arrived here with the crew in good health, with no injuries onboard and without any mechanical breakdown on the boat. Perhaps that short, yet moving prayer that Tania whispered had also been heard that time around.

I miss my son and my wife and the rest of the family but I know this time apart will only strengthen our relationship and love for each other.

I'm still in Opunohu Bay, on Moorea. I'm going a bit crazy again because of this loneliness. In a few days my wife will join me for the coming two months while we make our way west and

hopefully I shall meet Sebastian in Fiji before setting out to the island of Tanna.

Until then, I read books or write, like now, my thoughts on this voyage and the people encountered along the way.

June 8, 2007

I just got back from the beach where I had a poisson cru and lemonade alone. It's tougher than I thought this being alone business. At the next table there was a young French family with two adorable children, boy and a girl. The whole family was very good-looking but the mother was a real beauty and I watched her as discretely as I could, studying her smile, her way of moving gracefully from one child to the other, the way she kissed the little girl and tried her straw hat.

For some reason it suddenly made me sad to see this beautiful family and I decided I couldn't take it anymore so I paid and left.

I missed my wife and twelve more days here alone seemed long. Petra and I have been together for twenty three years. She was my high school sweetheart and remained my true love for all these years. We've been through a lot together, she was my secret confidante during the years I tried to escape Romania, we went to university together, and we had a son, Paul, who's almost eighteen now. I left the country only three weeks after his birth. Next time I saw them was two years later, in Sweden. I missed a critical time with my son but I knew that my only chance was to leave that year, before they closed the borders again. We had a hard time reuniting as a family in Sweden and we felt estranged but against all odds we succeeded and started building a new life for ourselves. Petra and my brother are today my best friends, the closest people in my life.

But the sadness was only a temporary state. I have never been more content with my life really. This is the voyage of my dreams.

I have a whole world ahead of me and my little sailboat is the perfect vehicle for such an escape. At five knots the soul can keep up with the change of landscape and contrary to what most people believe the sea has many landscapes.

The passage from San Diego to French Polynesia had been hard and I was still recovering from the brutal ride south. Flavio, Dino and I took a beating on the way down, in our long search for light and warmth. Like coalminers emerging from the darkness of the deep earth, we celebrated light and warmth as indispensable prerequisites for life. I remembered when we finally changed to shorts and sailed the warm nights under a canopy of stars, with Orion on one side and the Southern Cross on the other. I remembered the peaks of Nuku Hiva, changing shades of blue as we approached the island. It all seemed so unreal.

Sunday, June 10, 2007

Sundays are very quiet in Christian Polynesia. Most everyone is in church, ladies showing the most extravagant of hats, men dressed in summer colors but conservatively, shirt and pants. The missionaries worked hard over many decades to enforce the present tabus in Tahiti and its islands.

I'm reading Paul Theroux's "Riding the Iron Rooster." I always enjoy contrasts and reading about his train journey through Europe, on the Trans-Siberian, Mongolia and to China here in French Polynesia gives me great pleasure.

It's a calm day today and a bit cooler due to the partial cloud cover which is good for writing and reading. Last night I made pasta with tomato and olive sauce and ate it under the stars, alone in the cockpit, with a candle on the table. I mixed some pineapple juice with a bit of Havana Club and watched the sky for a long while. Solitude changes you and I started noticing these changes in me but it's too early to make an opinion.

Today I'll stay on the boat and enjoy reading.

Monday, June 11, 2007

I drove the dinghy to shore today, in an attempt to make it to town. The dinghy had collected some water from the overnight rain and I had to drain it on the beach. I waited for an hour and a half on the side of the road, waving cars in vain. But one fellow in a white old Renault van did stop and we chitchatted in English all the way to the restaurant *Le Motu*.

The restaurant turned out to be closed on Mondays and I thought my plans for the day were ruined but he drove up a few hundred yards where there was a shopping centre, a bank and a restaurant which was open. The restaurant turned out to have an internet café in the back. That's how I got the news that Bo and Katarina separated. They now live about three hundred meters away from each other, in two separate apartments. This may have been the closest they've been to each other in a long time. Bad news of course, and I felt sad for both my friends but such is life sometimes. I simply have no comments on this. All I feel is sadness and a sense of emptiness.

I had lunch alone at the restaurant, bought a baguette for the evening, and a *Thallassa* magazine.

I wonder if the French waiters go to some asshole school because they all seem to be uniformly rude, arrogant and impertinent. And I'm very split about that: there is something I like and something I despise in them but I'm not sure exactly what. Eventually they all soften up when they hear I'm Canadian and not American but it's too little too late to repair the damage.

On the way back I took a taxi with Mr. John Teamo. Difficult to say if he was Chinese or Tahitian or both but his English was good and he gave me some goodwill advice.

"Please don't leave your dinghy here. If you want I can drive you to Ann and Coco's place on the west side of the bay. Ann speaks good English, she's been in America many times. She's

into the black pearl business. I'm sure you can leave your dinghy safely on their beach."

And he drove me, free of charge, to this lady's house, he showed it to me, then drove me back to the boat.

It's when you are a vulnerable traveler in a foreign world that you most appreciate the kindness of strangers with no purpose of gain or profit. He could have dumped me there, he could have overcharged me. After all, I'm just another clueless westerner passing by, right? But he didn't. Just like the young fellow in the morning slammed on the brakes and picked up this bearded stranger looking worn out and fed up.

But of course it would be naïve to think that everybody is friendly in Polynesia. A pretty girl from Rangiroa named Kihuna told me about the rapes and murders and fights that happen frequently in the happy isles. A Dutch family anchored in Opunohu Bay told me that everything was stolen from their Zodiac except the dinghy itself, oars, life jackets, gas tank. And John, the taxi driver warned me of robberies in this area as well. And what I find very odd is that when you speak to the Gendarmes they start laughing as though it's always your fault to think people are not going to steal from you. I was robbed once in the south of France and the attitude there was the same: if you got robbed you're an idiot, you should have been smarter and take the necessary precautions. I'm always very careful because I grew up in a damned place like that where people thought exactly the same but it's very difficult to carry a dinghy around Moorea, no matter how street smart you are.

Wednesday, June 13, 2007

Rough day today. I stretched in the morning and screwed up my neck again. It worries me because it usually takes me three months to get back to normal and with 4,000 miles to go to New Zealand and all the physical work involved on a boat this can

develop into a serious problem. I took an aspirin and then went swimming in the afternoon and the pain subsided somewhat. At five I decided I would go for a walk to a little snack bar where locals get their poisson cru. I intended to be back before dark but I miscalculated the distance and after walking (running) ten kilometers in the night and being chased by ferocious dogs I finally returned to the boat exhausted and fed up.

Tomorrow I'm off to Papeete to get the wedding rings. I'm going to propose to my wife again, for the next 20 years. I decided that every 20 years I either divorce her or ask her for another "term."

I chose a pretty Marquises design for the rings and a pearl necklace for her birthday. Hopefully she'll say yes.

Thursday, June 14, 2007

Papeete, called Pe, had pizza, rings not ready yet. Witnessed a bizarre event today: a French pimp interviewing new girls for a new "position." The girls looked like they were from the outer islands, perhaps the Tuamotus. He took them one by one to another table at "*Trois Brasseurs*" and pretended to be dead serious and professional about it as though he was hiring flight control officers. Very sad indeed. A sleazy, oily fifty-some year old white trash exploiting the naïve girls from the remote islands. Tahiti is a sad place. The world is a sad place for that matter.

On the ferry I met a pretty Chinese couple. *Nouveau riche* generation, innocent and naïve, but optimistic about the future. Then I went to Ann and Coco and listened to their stories about the rich Americans on the island, about everybody there smoking pot, about independence and the French connection. I took the bus back to the anchorage and it was interesting to see their system when waiting for a ride. They break some tree branches from the side of the road and leave them on the tarmac. That's how the bus driver knows he has to stop. In the meantime you can go about

your business without having to wait in the street. Coco gave me a bag of fresh fruit: papayas, bananas and pamplemousse. Topless women on the beach, I found that very tormenting.

Went swimming to cool off. The Germans in the 200-year old schooner left. Alone again.

Saturday, June 16, 2007

Brought Ann's son and his friend onboard. They made a mess with their dirty feet and the biscuits I offered them. They asked lots of questions: where's the stove, do I have a fridge, can I call the world over on the VHF radio, where do I sleep, how do I steer at night, and am I ever afraid, was I alone, why was I alone, where was my wife and so on. Intelligent kids asking very interesting questions. Then we went on deck and the questions continued. The sails, the mast, the anchor, the solar shower, why was the boat still moving if we had anchored and so on. The other kid asked if I had a TV onboard and as I said no, Ann's son lifted his arms and said:

"Who needs a TV when you have this?" and he showed the magnificent mountains surrounding Opunohu Bay. He looked like a little Polynesian king, with his arms in the air and the proud eyes scanning the majestic mountains surrounding us. It warmed me to hear a seven year old boy speak like that. As we continued our conversation he explained how Moorea was created by a volcano and how Opunohu means "lots of rock fish." Then he went to the wheel, steering, screaming to an imaginary crew on deck:

"Equipage, tirez les voiles!"
And the other kid responded:
"Oui Mon Capitaine!"
This went on for more than half an hour and I was reveling in this kid's imagination. You could see that he was out there on the ocean, screaming orders to his men, sailing to a distant continent

as his Polynesian ancestors had done for centuries during the great migration.

"Moi j'aime la navigation," he said.

I left them on shore, which was their backyard, and long after I could no longer distinguish their silhouettes I could still hear their excited voices telling the mother all about the ship from Canada and the lone sailor.

Many a winter night I lay down on the floor in my room upstairs, watching the light of the flames from the fireplace dance on the ceiling. I'd lie there hours on end, just daydreaming, having visions of places and people I'd meet in the future, pre-living the life I wanted to live. Father would sometimes come upstairs and force me out in the snow, skis on my shoulder, woollen hat on my head. He worried I'd get too apathetic and fall into a winter depression. I wasn't depressed; I was maybe more meditative than he wanted me to be, spending too much time brooding about the future.

Now, I was more and more looking back in time rather than forward, a sign of age, I figured. I was forty but I felt much, much older. It wasn't physical ageing -- I was in better shape than ever before -- but it was more a mental fatigue, as though I had seen too much too early, and maybe I had seen things I shouldn't have. Maybe it is good to take the time and go through life slowly.

My boat sailed slowly across the world, but it was the images of the past that raced each other like storms across the vast expanses of the ocean. Every life is a puzzle with missing parts. Some of us look for these bits an entire lifetime, others die wondering how their lives would have turned out if some of the cards had been played differently.

Others are resigned to acceptance.

Sometimes I wonder what it would have been like to grow up and live in the same place my entire life. What would it be like to drive my child to the same school I went to, to see all my friends

grow old with me in the same landscape we used to play, in the forests of the mountains, watching our children swim in the same river we used to swim in our youth?

What would it be like to walk the same path every day and have memories pop up in my mind around every corner on my way?

I remembered a friend of mine from Sweden, Kerstin, who took care of me when I first settled there. She drove me around the countryside in her blue Mercedes, showing me where she grew up.

'And there's my parents' house, and right across the street is our farm. The red house on that little hill is my sister's. There's the school we all went to, and on the other side of the lake lives my daughter and her husband,' she'd say.

Sometimes I envied those people. When I was younger I wanted to see the world. Later on I wanted a place to call home.

But once a nomad, always a nomad.

I thought about my parents.

Father would soon turn sixty-three, and Mother sixty. They were still relatively young and should have a few good years to go, but then again, their life hadn't exactly been a dance on a bed of roses. After I left the country they had two more children, Andrei and Ioana, so they had to start bringing up a new generation from the beginning. After fifteen years of separation we were all reunited in Canada. Canada had become our home and we love that country more than our own homeland. In fact, Canada is our homeland and we're proud of that.

Our little brother Andrei grew into a handsome young fellow, playing soccer for the Montreal junior league, and Ioana applied for a degree in journalism at Concordia University.

Before we managed to bring them to Canada my father used to feed his family on his hundred-dollar pension. After all he taught for forty years, what more could a man ask for?

To make ends meet, he painted northern landscapes in oils and sold them around Europe, some of them even on Montparnasse.

Mother painted hollow eggs with intricate Byzantine patterns and sold them successfully both on the old continent and in North America. That way they also travelled to see the places they had dreamed about.

Sebastian and I are two very different characters. When we were kids, we used to fight a lot, then as teenagers we just ignored each other, living in two separate worlds, one unaware of the other's.

He was the good kid, though. Father would take us to the tennis courts for days on end. When I lost I swore and threw the racket, smashing it into the tarmac, or the nets or into the high fence that surrounded the court. Sebastian prayed to God.

I broke the rules more often than not; he was always obedient and quiet, never arguing about anything, rarely questioning others.

I can't count the number of injuries I inflicted upon him during our childhood. Nothing ever ticked him off. He'd come back to me with my arrow stuck under the skin of his head, smiling. There was some sort of permanent aura of content about him, as though a higher power promised to protect him from any harm.

As a baby he had a big head posted on a thin neck. When we called him, he'd take ages to turn his head, as his neck lacked the muscles to carry it around. It'd just swing sideways, like one of those puppets on springs.

As a boy, he was skinny and kind of wimpy-looking. By sixteen he was still skinny but grew taller than any of us, so tall, in fact, that he could hardly co-ordinate his limbs. He got into basketball and break-dancing, the latter being very appropriate as he often looked as though he'd break every time he walked by.

Then I didn't see him for a while. He was called into the army and next time I saw him, seven years later, in the Frankfurt airport, he was six foot three and over two hundred pounds; all of it bones and muscle. But I knew that something had happened because he was a different person altogether. There was strength

and determination in his eyes, but also a deep sadness, like an open wound on his heart.

Anyway, I wouldn't mess with him now. All his fears of darkness, heights, animals, insects with all the related phobias, are gone. From the jungles of French Guyana to those of L.A., from the predators of the Kalahari Desert, to the cold darkness of the Arctic, he's done it all and he'll be back for more, for this is payback time for him. All the frustration he built up as a kid paralysed by fear is now channelled towards accomplishing great feats of endurance and skill while at the same time helping others to overcome their fears.

He left the country a couple of years after me, when I totally lost track of him. I knew I had a brother somewhere in Africa, and that was about it. He went to Cape Town and studied theology, then moved to Montana and worked as a pastor to a remote community before ending up in Calgary, working with young adults as a youth pastor.

Later he founded *Pilgrim Society*, a non-profit organization for education and relief of poverty, driving projects on three continents. From the Bushmen of the Kalahari to the tribes of Caribs, Taurepan, Waica and Arecuna of the Amazon jungle, and from the isolated villages of French Guyana to the outposts of humanity in the Arctic, *Pilgrim Society* built schools, water systems, churches, orphanages, it paid for the education of young children and medical care of many people. During his last project, he took twenty-five North American teenagers to Africa and opened another world for them, building water solar powered systems, orphanages and schools.

Sebastian went first to the Kalahari Desert in January 1995 as a research student trying to write his final paper for a university in Cape Town. In the middle of the African summer, when the Kalahari is the least hospitable place on Earth, Sebastian left for the unknown, armed with a backpack and very little money in his pockets. He travelled 1000 miles from the nearest town,

sometimes hitchhiking, more often walking through the desert. One chilly evening, as the temperature dipped below zero (as they will at night), he stumbled upon the village of !Ukuarama and was quickly surrounded by curious Bushmen.

He sat down by the fire and explained that he was there to stay and learn. Naturally, they did not understand a thing he was saying, being more preoccupied and worried about how they'd feed him, since he looked like a giant to them. Food is sparse and difficult to get in the desert and the Bushmen spend most of their energy and skill to procure it, mostly by hunting. The prospect of having to feed another hungry mouth was reason enough for them to worry, but Bushmen also have a subtle sense of humour and so they called him Kamuanga, or Big White Beast.

Nkao, the Big Chief, welcomed him in the big family and they spent the rest of the evening watching the fire under a big black sky, where stars shine bright in the desert night. Once in a while, Sebastian thought he'd noticed a faint smile on the chief's face, a sense of contentment about the future that the stranger might bring to them. Sebastian realized that he had stumbled upon something that might just change his life, and a few others, too.

That marked the beginning of Sebastian's lifelong relationship with the mysterious little people of the Kalahari Desert. He is today the only living white Bushman in the world and, perhaps, the only voice that speaks in favour of that people in Western society. He realized that unless he did something about it, they would be extinct as a race in our lifetime. Pushed away from their lands by the South African government, they lost access to the water and game that had been their source of subsistence for thousands of years.

Suddenly these masters of survival were not able to bring any food home, and watched their beautiful children face starvation and death.

Sebastian has returned there every year since, bringing help to their world, while making our world aware of their frail existence. The *Pilgrim Society Foundation for Education and Relief of Poverty* was then born and tens of thousands of people listened to Sebastian's stories about the Bushmen of the Kalahari. He built solar water pump systems, schools and orphanages for the Bushmen; he brought supplies of blankets, medical equipment and medicine. They gave him another name, Po, or Jackal, protector of the children who comes and goes at night in silence. Gaukana, the Bushman that appeared in the movie, *The Gods Must Be Crazy*, became his best friend.

Every year Sebastian goes to the Kalahari like the aborigines go on their walkabouts, like I go to the ocean, on a holy pilgrimage that ceases to be a desire, but becomes a necessity.

That was his journey from the little mountain village to the remote corners of the world, his nomadic search, and his pilgrimage.

Dream of Africa.

As we approached the shores of Walvis Bay in the afternoon sun, thousands of pink flamingos lifted from beach to purple sky. Hundreds of seals surrounded our boat, vociferating energetically. Large waves crashed on beaches that stretched as far as the eye could see.

It was another world. It was Africa.

The following morning we were in a Land Cruiser zooming through the bush on our way to the Waterberg Plateau where we would set camp for the night. Baboons were watching us work in the heat as we put up the tent, and I immediately noticed that smirk on their faces, the sort of "I'm smarter than you are" attitude. At four a.m. the next day we climbed the mountain in pitch darkness,

listening to the sounds of the jungle as we scrambled up each rock along the way to the summit. The cry of a hyena out in the darkness, the echoed scream of a baboon chased in the woods by a predator, the delicate song of a secretary bird resounding from the acacia trees: what a change of environment from a day before. The amount of external stimuli provided by land life was pleasantly intoxicating.

We made a fire on the summit and waited for the sunrise in silence. With every inch the sun rose higher, the light on the red rock shifted in intensity, from deep carmine red to pale orange. And from the top, the immensity of the landscape overwhelmed us as the light unveiled the desert from the warmth of the night. For as far as we could see, the Kalahari, which means The Great Thirst, stretched in front of our eyes like an ocean of golden grass, acacia and small bush. It was absolutely immense and it took our breath away.

Sebastian put an arm around me and stretched his hand out over the vast space.

'Here's where the world started, brother,' he said, 'this is the Great Thirst, the womb of humanity.'

'Great Thirst as in lack of water?' I asked.

'No brother, that is the little thirst…there's a great thirst out there for all of us. Think about it…' I had forgotten that Seb had spent seven years with the San Bushmen of the Kalahari and that he had learned more about that place than any other white man alive.

I descended that mountain with a sense of spiritual awe and fervent expectation for my meeting with the Chief the day after. The baboons had opened our "baboon-proof" food box and robbed us blind of everything. We threw a few wood stumps after them but it was nothing but a good laugh for them. On a large area of about thirty feet there were rests of cornflakes, nuts, sweets, fruit, biscuits and so on. I tried to save a jar of honey but one of them beat me to it, snatched it and ran along, looking halfway behind and sneering at me.

Next morning we stopped for breakfast on our way to the desert and enjoyed fresh guava fruit juice under swaying palm trees while the horizon flickered under the increasing heat. We then drove a whole day and then another day on a straight white-sanded road until we came to a barrier. On it there was a sign posted by the Namibian government.

It said: "Now you are entering the sacred lands of the Kalahari Desert. Due to the inaccessibility of the area, the Namibian Government can no longer be responsible for your well-being and safety beyond this point. You are entering this area at your own risk!"

A thin 'Mbukushu warrior lifted the barrier and we drove through.

I was happy. I was happy not only for being in that unique place, but for entering the realm of my brother's magic shelter, for getting to know more about his past from the time we parted. Minutes after driving in the desert, small Bushman groups emerged from the bush, waving and shouting in their clicking tongue. Seb lowered his window and responded to all of their greetings:

'A qua che, Bastian!!' they shouted.

'Mijam'Ba,' he'd answer back, smiling. They laugh and jump with joy and the children left trails of white dust behind them as they tried to keep up with the four-wheel drive.

They loved him there, and his heart smiled every time they greeted him. It was very touching to watch the play between them, the laughing eyes, the signs, the winks, it all proved a common past and an intimate history together.

Sebastian drove to the hut village and in no time we were surrounded by children, women carrying babies in their arms and old, really old men and women.

'These are the oldest people on Earth, brother,' said Sebastian, 'you could say they're our ancestors on this planet. Look at them, how beautiful the children are, and no one knows their age because they don't have any notion of time. See that old lady over there? She

might be over a hundred, but if you ask her she won't know, because she doesn't care.

This desert is their backyard, and the San are the last survivors of the first people on Earth.'

His voice changed, he was in a sort of trance, he was in a way back home, where he belonged, and that people right in front of us was the subject of his lifelong fascination with Africa and its secrets.

They started talking again with that clicking noise and the Chief appeared from the crowd. They bowed for each other and the thin, old man touched Sebastian's forehead like a father seeing his son return from his travels in the world. Then, Sebastian told him something and they both turned towards me. The old man looked me in the eyes and winked once. A faint smile appeared on his face and he approached me slowly. He put his hand forward and I squeezed it lightly with both my hands. He held on for a second, without letting his eyes wonder away, staring deep into my eyes, perhaps trying to find similar features with my brother, or a parallel beam of light. He then said something and Sebastian nodded and smiled.

'He calls you Gxui. That's your Bushman name, bro, Gxui!'

'Meaning?' I looked at him, wondering.

'It means, ONE, brother, number one. Beautiful name, wouldn't you say?' he said laughing.

The Chief continued talking. He said the village had cleared up a huge space, a circle, in the bush for a welcoming ceremony that evening. And with that being said, he smiled and turned back to his hut.

We set camp out in the bush, under a big acacia tree. We made a small bushman fire and cooked sweet potatoes over the hot ambers. We hung a rubber container from a branch and in that way we had a great outdoor shower.

What a feeling to stand in front of a huge sunset, showering naked in the bush! The crickets singing through the tall, yellow grass, the dark silhouette of an acacia tree standing out against the crimson sky: it was magic.

That evening we gathered around the fire together with the whole village and witnessed an incredible show of dance and song on a background of drums and handclapping. They were all there, participating in that fantastic social event, from a two year old wiggling his belly from one side to another to the old chief who beat the dust until midnight. I sat speechless on the ground the whole evening, fascinated by the warmth of their welcome, unable to find anything strange or unfamiliar about that primitive tribe I had never met before. Then I wondered if we really did make any progress as human beings since the time the Bushmen emerged in Africa 30,000 years before us. Yes, we could fly to the moon, but were we better beings that those people of the desert that lived the same way since birth, without making any claims to own anything or anybody?

We thanked them with presents and food products they liked, like Lipton tea (the Bushmen love having English tea), garlic, rice, flour, sweets for the kids and so on. Unfortunately, the Bushmen eat English porridge three times a day. The whites pushed them out of their lands, the animals they used to hunt have been removed and relocated within private safari parks, and now they were totally dependent on foreign help, just like most of the African population. Sad story.

As I thanked the Chief and was about to walk to the car, he mumbled something that almost sounded like a verse out of an ancient poem. Sebastian nodded and translated:

'He says go back north and search for the freedom you had as a boy. You will not be whole again until you find it. You left your land for freedom, then you became a prisoner again.'

I shivered at the low whispered voice, at the singing words ringing in the night like bells resounding in a valley.

"Ideas are like stars, you will not succeed in touching them with your hands, but like the seafaring man on the desert of waters, you choose them as your guides, and, following them, you reach your destiny." (Carl Schurz)

No sleep last night. The past is haunting me again.

Fifteen. Why does everything happen when you're fifteen?

On my birthday I went downstairs and told my parents I would leave the country.

They sat down in silence, listening to me attentively. As soon as I slammed the door behind me I heard my mother:

"Puberty! It's arrived!"

I was only fifteen, but I had no fear and an almost suicidal will. For the next five years I tried almost everything I knew about and failed at it miserably.

I tried hiding in trains; I was a hundred feet from the fence separating Romania from Hungary when the bullets started flying around my head. I hid in trucks loaded with industrial washing machines going to Italy; I got stuck in a whirlpool in the middle of the Danube hanging onto a truck tire. I even tried to steal a small plane from an apple orchard, but ended up in a barn with a few bruises and an expensive bill for my parents to pay.

Nothing worked.

My file at the Securitate, the Romanian KGB, was getting bigger and bigger and after I got caught my parents lost their jobs for a year. I wasn't thrown in jail only because I was under eighteen, but when I finished high school and the time came to join the army, they assigned me to a coal mine in southern Romania, which was almost like a death sentence.

I remember leaving my parents in the small train station of a snow covered mountain village. I remember how they became smaller and smaller as the train gained speed and plunged into the frozen darkness, its horn howling through the valleys like an enraged beast. I could see them from the little hole I melted with my breath on the icy window. They looked smaller and older and sadder than ever before. I knew they were wondering if I'd ever come back home. Not many kids sent to that labour camp did. Some of them returned without limbs, others traumatized for

life, and others came back in a coffin, their bodies wrapped in the Romanian flag.

On the way across the country, onboard a rusty old train, I met a man who was to become a good friend. He had been given the same sentence. His name was Dan, and to this day he's still one of my very best friends. We smoked nervously day and night, wondering what fate had in store for us. The train arrived at a frozen desert after two days and two nights.

Matasari, a perfect name for a place in hell. There was an evil resonance to that name from the very beginning, I thought.

Matasari was a God-forgotten village in the Jiu Valley, the main mining district of Romania. Except for its mineral riches, the area is known for its rough people and for the capital of stupidity, Calarasi. In Calarasi, there was evidence that the city was home to the most extreme cases of idiocy on the planet. Dan and I were merciless in enumerating them:

One: In the centre of the city there is a statue of a great king holding his sword towards the sky. The sword is bent like a new moon, but the sheath hanging at the king's waist is straight.

Two: Twenty years ago, a crane was used to build the two L-shaped buildings around it. Today it still stands there, trapped between the very walls it erected.

Three: The road that circumvents the city centre is called 'The Circle,' only the two ends never meet, one of them dissipating suddenly in a dead end street.

Four: The prison is located on Liberty Street, the cemetery on Vitality Street and the mad house on Peace Boulevard.

When we arrived, we found black dunes of coal everywhere and houses made of clay. Everything was covered in coal. Chickens lived in trees, and pigs were chained to tree trunks in every garden. Derelict buildings sprawled everywhere, animals behaved like mad, and people looked trapped in misery, sentenced to life there forever. The whites of their wild eyes shone like neon-lit billiard balls against black, sooty and devilish faces.

It looked like nothing I had ever seen before. If the rest of Eastern Europe was grey and decayed and depressing, this place was downright horrifying.

It felt like a nightmare. It looked like hell.

We walked for an hour on narrow country roads, across railways and mounds of coal. Then we entered the metal gates of the military compound. We gathered with a thousand other doomed souls and stood in the middle of a large cement square flanked by barracks. And there was silence. Black coal powder floated in the air. A large billboard depicted a miner coming triumphantly out of the depths of the earth. He had a heroic smile on his face. Beside his face, the text said:

'We like to work, not to think!'

And there was silence. There was nothing to say.

Soldiers appeared from the barracks and a fire truck pulled in front of the crowd; we were told to remove our clothes and throw them in the plastic sacks they provided. Then they sprayed us with DDT, a white toxic powder used to disinfect animals. The soldiers detached the hose from the fire truck and pointed it towards the crowd.

People fell on the ground at contact with the high-pressure water jet, piling up on top of each other, forming a heap of naked bodies contorting in panic. There were screams of shock and pain.

It was January 17, 1985.

After a while, when the water was cut off and the laughter of the soldiers ceased, we were told to get into the barracks. Inside there were more soldiers standing behind a row of chairs waiting for the next phase of their entertainment.

Shivering and in shock we stood in a line, then, ten at a time, we were told to sit to have our heads shaved. It went fast; no one was on the chair for more than half a minute. An hour later there

was a sea of shaven heads, shining in the dorms like human light bulbs.

They gave us uniforms and divided us into groups of twenty, the usual size of a platoon.

Our leader was a dark-skinned fellow of Turkish descent. His name was Mustafa. He lined us up and inspected the uniforms. He had a malicious look in his eyes and a faint smile under his thin, black moustache. He paced up and down the line, swearing between his teeth and hitting his new subordinates. When he stopped in front of me, I looked into his eyes and we sized each other up. Before I had a chance to react, he took a swing at me and knocked me right between the eyes. I fell on my back and lost my eyeglasses under a metal bed. My nose started bleeding heavily, tears flooded my eyes as a result of the punch and I suddenly got dizzy.

I stood up and looked into his eyes again. He struck again, but this time I ducked away. As I thrust my head to the side, he missed and punched the air, but inertia pushed him forward and I lost balance and fell a second time on the floor. He regained control, stood up and started kicking me in the stomach. I felt the heavy boots penetrating the uniform, leaving the rough imprint of their soles on my skin. He went at it until an officer entered the room and screamed at him to stop.

'I don't want any eyeglass-wearing smart-ass intellectual in my platoon,' he whispered in my ear. 'I want people who work, not think!'

The officer turned out to be Dr. Stefan, the physician of the battalion. He kneeled down beside me to take a look. I was gasping for air while spitting blood on the linoleum floor.

'Bring him to the infirmary!' he said. 'And come and see me later, corporal!' he added.

Then I passed out.

After a short time at the infirmary, I worked for three months down under, three thousand feet underground in the deepest

coalmine in Europe. Due to non-existent safety procedures, accidents occurred daily. It happened quite a few times that I carried my mates' limbs out of the coal mine and even helped carry bodies to the surface.

I worked days and nights in water up to my waist, smashing rats on the uneven walls of the man-made caves, eating mouldy bread and drinking bad water. We carried four hundred-pound reinforcement beams through holes no bigger than our waists for long kilometres through the guts of the earth until some died of exhaustion or simply because they wanted the nightmare to end.

At one point, Danny and I even considered suicide. Although I was a natural-born optimist, all of a sudden death looked like an escape. We had coagulated blood under the skin of our shoulders from carrying the heavy loads. We were constantly exhausted, hungry, confused. Our minds hurt, our bodies ached, our hearts cried. But who to ask for help? We were eighteen, thrown in a hole where our mates died almost every day; we were underfed, harassed, beaten up, scared, depressed and lonely. Who to ask for help? We were soldiers under orders, we could not disobey, we could not protest, our parents had no idea of the conditions we endured, our officers were themselves stranded there for disciplinary reasons, so who could we turn to?

Throw a few thousand Western teenagers in a place like that and see how many would make it...

Anyhow, we discussed the subject at length and concluded that it wasn't worth dying in a hole like that. If we were to die, we'd be better to do it on the fence trying to get out of that cursed land than ending up ground meat for the coal grinders.

Thank God for the idealistic mind of a teenager. The dream for a better future somewhere else on the planet saved my life.

And so, at the ceremony where all soldiers pledge their faith to the homeland, when a thousand hardened kids are to loudly swear allegiance to their country, Danny and I exchanged the name of the country we'd be faithful to. In the roaring voices of the crowd reciting the national allegiance text, we swore allegiance to Canada, and all of a sudden it all made sense.

'Oh Canada, we stand on guard for thee…'

Canada became the distant light at the end of the tunnel.

After those three months Dan and I, together with a few others with somewhat better education, were selected for office jobs at the senior officer's headquarters, an imposing white-walled building on top of a wooded hill.

Dan was appointed telecommunications operator and was in charge of the telephone switchboard, while I ended up as General Bahcevani's personal secretary. That change might just have been another thing to save my life, because a week after I moved to the 'quarters' as we called it, an earthquake buried two hundred people alive, injuring more than a thousand. I helped with the clean up afterwards and those heavy steel reinforcements were bent like spaghetti. I cried every day as I went through the rubble of metal and bones and asked myself why I had been spared when so many of my friends ended their lives there. I was eighteen and I already felt guilty for living, and even now, after so many years, I have the feeling that that I'm on overtime, on time extended, that I should have ended there.

Becoming General Bahcevani's assistant was no blessing, except for the fact that it got me out of the hole. At five in the morning his boots had to be polished and his instant coffee had to be just warm enough for him to sip it without getting burnt. He was a very severe-looking man, high in his saddle, proud and unforgiving. His blue-grey eyes had a piercing force, intimidating even superior officers at the quarters.

As for myself, he terrified me. I worked twelve hours a day to accommodate him and to organize every aspect of his job as well as his private life. I drove him around several bases in his jeep, prepared his speeches, set up his meeting schedule, painted his slogans on big metal boards and placed them everywhere in the compound, answered his phone when he didn't feel like it and lied for him to soldiers and officers alike, not to mention the stories I had to make up for his wife when he was visiting his *amante*, a tall brunette working at the village library. Yet I knew that if I made one mistake, one little mistake, he would crush me without a second thought.

I did eventually leave. Eight years later, with a passport in my hand, just after Ceausescu got executed. Very unspectacular, very non-Hollywood, very un-hero-like.

But Sebastian suffered the consequences of his brother's subversive past. He, too, was sent to a labour camp, although he hadn't ever done anything wrong in his whole life. He was sent to the railway works, those, too, in the south. He worked in excessive heat and subhuman conditions and ended up almost dead in a hospital in Bucharest. But that is another story.

Sunday, June 17, 2007

Woke up in the morning with the boat rolling from side to side and an outboard engine buzzing around. I came out in the cockpit, hair wild as usual at that hour, and started screaming at a bunch of youth driving around in their daddy's fast launch, pulling a water skier behind. I think they got scared because they went back to the ten-million dollar yacht appropriately called *Bullish*. Cayman Islands. Bankers. The kind of people I'd like to send to Fidel's camp.

Their revenge came in the afternoon when the youth returned. This time there was one young man and two girls. One of the girls

was particularly attractive and I watched her standing on a surf board, gliding over the water effortlessly. I was admiring her shiny body and her athletic figure in the afternoon light when the guy drove really close, looked at me with a jeer and then turned the boat away. I was sorry to see them go this time. I wouldn't have complained again. I guess we're objective only as long as it serves our interests.

I took a nap afterwards and woke up in a sweat. I quickly went out on deck and dived into the fresh water. As I sat on deck afterwards, I looked around at the golden shades of yellow of the afternoon light and I realized that I really loved this place. And this place had become home. This is what changes a traveler, if he chooses to stay in a place long enough. I knew that later on, during the harsh Montreal winter I'd be lying in bed at night, watching the ceiling and dreaming about the South Pacific.

"You will never be happy if you continue to search for what happiness consists of.
You will never live if you are looking for the meaning of life."
(Albert Camus)

From the memory shelf: a visit to Romania.

We went through customs at Otopeni Airport in Bucharest. Chic boutiques packed with Christian Dior perfumes, fine cigars and expensive Cognac adorned the pathway to the exit. Small Internet cafes showed up every now and then and the smell of cappuccinos blended with the noise of fingers tapping the keyboards. It could have been Amsterdam, London or Paris, one couldn't tell the difference, except of course the different language spoken all around.

The shops were tended by slim, tall brunettes wearing Italian clothing and smelling of French perfumes. A trained eye could even notice the discreet contour left on their short skirts by Calvin Klein underwear.

I hadn't expected that. They sucked up capitalism like sponges thirsty for water. Young teenagers gesticulated wildly while speaking on their mobiles; kids chewed American gum and wore Levi's jeans; old ladies sat down watching their grandchildren play with wildly coloured plastic balls in the play areas at Macdonald's.

The young personnel at the information desk spoke perfect English and had adopted the same nonchalant attitude as any international airport clerk.

The confidence of the new generation was shocking.

We went out, looking for a taxi. Big Mercedes SUVs zoomed in and out in front of the main entrance; brand new Volkswagen minivan taxis pulled over and took off after loading luggage and people.

Then, over there in the dark, we noticed a group of children sitting on the cold cement floor, sniffing glue from stained, brown paper bags. It was the end of January, and they were dressed in rags, showing bare feet in oversized, holed shoes, and dirty red, frozen fingers.

Sebastian put his rucksack on his back and turned towards them. I followed him.

They were around ten, maybe eleven years old, and I thought about my son when he was that age. We sat down next to them, watching. They looked through us, as though we were transparent.

Their eyes were lost somewhere, perhaps in a better world.

A small, wild-eyed fellow with curly hair came to me and said:

'You wanna see a trick?'

I smiled.

"Sure,' I said, 'show me, Mr. Magician.'

'One dollar,' he said.

'One dollar?' I exclaimed. 'One dollar?'

'Yep, if you wanna see.'

'Wow, you're a good negotiator, buddy. I thought this country's currency was the Leu (Lion) not the dollar.'

'The dollar is king here…are you gonna pay or not?'

I rubbed my beard for a second, pretending I was contemplating his price.

'Tell you what,' I said. 'I won't give you money, but I will buy you food for a dollar. How's that?'

He thought for a while, looking back at his friends. There was a girl there, too, but she turned her back to us.

'Mmmm-okay,' he said finally.

We were waiting eagerly for his demonstration when he pulled a razor blade from his dirty pocket and shoved it in his mouth. He moved it around from one side to the other, using his tongue to flip it, turn it and manoeuvre it. Then, suddenly, he slapped his face violently several times, until blood trickled from the corner of his mouth.

We jumped up, shocked with his behaviour. I grabbed his head, while Sebastian opened his jaws wide and extracted the blade. Then he violently pulled himself free and ran away without saying a word.

My hands were shaking, and a nauseous feeling overcame me. I looked at Sebastian's blood stained hands and the blood-covered blade on the ground.

Then the little girl came towards us. She stood in front of us, rubbing her big belly and asked:

'Do you want to listen to my baby? One dollar, and you can put your ear here,' she said.

She wasn't older than eleven or twelve.

In that moment, a BMW swished by, throwing a wall of slush on us.

'God damn it!' I said, wiping the cold, dirty, wet snow off my face.

Sebastian gave me a severe look.

'It's not his fault, brother,' he said.

We went to the rest rooms inside the airport and washed up. My jaws were clenched together and I couldn't stop swearing. An old rage was reborn in me and I had forgotten how it felt.

We called an ambulance, but when they asked details about the emergency, and we told them about the street kids, they started laughing.

'You want us to waste precious diesel, and to go through peak hour traffic for some glue-sniffing kid? You must be joking. The quicker we get rid of them, the better!'

They hung up. We then stopped a policeman in the airport but he gave us the same message: they were an embarrassment to the foreign visitors and investors and they should be exterminated.

That was the modern Romania we found. A hardened, greedy Romania that tasted the sweet taste of the mighty dollar. I then realized that communism and capitalism had one thing in common: they were both about taking, not giving. The more one accumulates, the more respect one gets. Despite the antagonistic ideological rhetoric, it was all the same.

We went to a kiosk, bought a bunch of baguettes, muffins, and drinks and left them on the ground in front of the children. Then we got our backpacks and hailed a taxi to the train station.

'Welcome to Romania, Brother Sebastian!' I said.

After the shocking episode in the airport, we sank into a silent apathy that lasted long into the night. The contrasts were dizzying. Romania was turning into the same type of state as its South American siblings: a state of two worlds, the rich and the poor. I imagined a Romania ten years later where cities were split between the new-built expensive areas where enormous villas were raised, protected by walls and armed guards and, on the other side of the road, the slums of the city, like we had just seen in Rio.

The train moved fast across the plains of the south, heading north, towards the wood-covered mountains of Bucovina. Our tired faces were reflected in the pale yellow lights of the compartment, jerking sideways at times, as the train changed tracks at high speed.

I didn't realize when I fell asleep; I just rested my head against the window and off I went into my other world, away from the tiresome present.

The train stopped with a last jerk and a loud noise of screeching brakes. Clouds of steam enveloped the cars as the few people emerged from their compartments and descended the iron stairs onto the platform. We threw the rucksacks on our backs and started walking on the snow-covered lane towards the village. The frozen powder squeaked under our shoes. The morning mist still hung around the tops of the mountains, and the firs were bending their branches to the ground, heavy with thick layers of snow. Smoke came out of the chimneys, and silence prevailed above the valley.

The sunlight fell on some slopes, while leaving others in dark blue shade.

We walked past the church with its sharp towers scratching the skies, and then past the school we went to as children and up the slope of our mountain. A shepherd dog barked somewhere up in the woods, its deep voice echoing in the valley. When we were about halfway up the slope, we stopped and turned around. We could see the whole village, its red tilled roofs, the frozen river, the logging plant, the parcels of land neatly divided in small sections, the railway, and the empty main road going west, towards Hungary.

'God, it's so beautiful!' exclaimed Sebastian.

We both breathed heavily, steam flowing out of our nostrils.

'Not much has changed since we left...' I said.

'Thank God for that, too,' said Sebastian.

A horse sled passed us, its driver saluting by touching the brim of his sheepskin hat. We waved and watched as the sled went by, leaving wide marks in the snow. The horse breathed vigorously, keeping the same constant rhythm as he proudly paced forward.

We arrived at the gate of our childhood abode, and saw smoke leaving the red-tiled chimney. The white chalkstone walls and the French windows blended with the snow-covered, steep slopes behind the house, and the red roof seemed suspended in the air against the whiteness of the landscape.

We heard an axe strike and saw Father outside, splitting wood.

Nothing had changed.

His body was slightly bent over the wide trunk, holding the log with one hand and striking with the other. White frozen hair showed under the narrow brim of his toque, above his ears. 'That's how I'll always remember him,' I thought, 'splitting wood on a crisp January morning.'

Sebastian lifted the iron hook on the gate and opened it wide. Father turned at the noise of the rusty metal.

'Dad!' cried Sebastian loudly.

He leaned onto his axe on the wood trunk and looked at us.

He stared blankly at us for long seconds, and then a faint smile appeared on his face.

'My boys...' he whispered with his hoarse voice. 'My boys are back.'

Sebastian rushed to hug him and I heard Father's dry and loud swallowing, his usual trick when he tried to stop the tears from inundating his old eyes.

They rolled downhill faster and faster, all three of them on the same bike. The little one sat in front and the older boy on the steel rack behind his father. They gained so much speed that their hair fluttered wildly in the air and the boys thought the skin on their faces trembled like a handkerchief held out the window of a fast train.

Then a tourist bus caught up with them and the man on the bicycle lifted his arms from the handles. People waved from the windows, some old ladies shook their heads.

The green pastures dotted with yellow flowers zoomed by until colours melted with each other. The downhill ride continued for a long while, like a deep tunnel to another time.

The bus disappeared, and they were left alone, with only the sound of the fresh spring wind blowing warm in their eyes.

Suddenly the man lost control of his bicycle and they flew into the air. They could see each other's bodies turning in the sky but they could not hear the screams. The boys could only see the fear imprinted on their father's eyes, and his lips moving in silence.

Then they hit the ground and rolled and rolled and rolled again, Earth and sky rotating continuously, like the front wheel of the bike, ripped free from its frame, rolling on downhill, towards the river. Dizzy and blind they stopped with a thud, one after another, first the little one, then his older brother, and finally, a few yards away, their father, flat on his back, breathless.

And there was that strong smell of grass, the fresh grass that comes out in May, and the warm earth, embracing, welcoming, blending with the strong resin aroma from the tall trunks of the spruces.

The little one watched the white clouds race each other in the sky. A bald eagle rotated effortlessly high above, scanning the ground. The little one breathed deeply but couldn't move.

The man stood up, aching with pain. He picked up the boys, one by one and carried them to the shore of the river. They hung like lifeless puppets from his strong arms. He laid them on the soft ground under the weeping willow tree and brought water in his palms. Rays of sunshine pierced the clear drops of water as they fell on the boys' lips.

He remained still for a moment longer, then opened his eyes and realized it had all been just a dream. Water dripped from the ceiling

of the tent, and the sun found a small hole in the fabric and squeezed a sharp ray through, all the way to the ground.

His older brother woke up a moment later, rubbing his eyes incessantly. The little one pulled down the metal zipper and opened the front of the tent. He stuck his head outside and saw his father buried waist deep in the fast moving water of the shining silver river. He wore his wide brimmed hat and high leather boots, whipping the long fly-fishing line above his head with rhythmic, graceful strikes, like a dance in the air.

The bicycle rested against the willow tree, ready for another wild ride.

I wanted to escape the past and here I was, on an island in the middle of the Pacific, going back home. The farther away I went the closer I got to home, my childhood, and the important people in my life. This comes as a surprise, I thought. This isn't working the way I planned.

Monday, June 18, 2007

Went to town for lunch and Internet. Spoke to Fabrizzio the waiter (half Swiss/Italian, half Tahitian.) He really wants to make friends now. He sat down with me and told me how to fish around the islands, how to catch crayfish and strange crustaceans that live in couples in holes deep in the sand. Supposed to be really good to eat. Then he told me about the UFO sect that was kicked out of the island by the mayor of Bora Bora after they started building a landing strip for the UFOs, about smoking pot.

"Za only sing I neva did was mushroom, because I don't want to get coco in za head, non?

He likes to use my name a lot.

"Christian, your poisson cru will be ready in four minutes."

"Chris, let me bring you some wata with zat espresso."

He didn't let me tip him today. He said he has his Americans that tip him big. He prefers them to the rest of the tourists. He told me also about the 300 bungalow Club Med that was closed across the street. 600 employees, mega resort, totally bankrupt.

He sailed from France with his father in a 36-foot steel boat. His Dad was an officer in the French Navy and was almost shot with his whole family when he entered the wrong bay in Spain where they had a military base. And then again, the same thing in Gibraltar, they shot in the air to warn him. Then he made a 5 degree error on the variation which brought him the Dutch Guyana instead of Barbados!

"My fazer made many mistakes, eh?

Five cyclones in Papeete and us on the boat zere in za harbor, eh? 1992, five cyclones in one year! I was eleven, crying, my brozer crying, scared to death and luckily za tow barge srew us a line ozerwise bye-bye, eh? Oolala, putaine de merde!

Zen, in Panama, he got hit by za bom? Understand, le mat ici, et apret le bom? Bom in za ribs, et voila, bye bye voayage au Pacifique du Sud!"

My beautiful wife has finally arrived. Life is so much more worth living now.

We took the ferry to Moorea, rented a small Citroen and drove to Opunohu Bay. In the evening, as the sun set, I took out the rings and proposed again. Twenty years ago we were in a steel-gray town in Eastern Europe, getting married in a seven-hundred year old church somewhere in the Carpathians. Now we were in alive, vibrant and colorful Moorea, twenty years later and in another lifetime. She said yes, as I was hoping for, so now I'm set until I'm sixty. I didn't know if I should laugh or if I should

cry. I kissed her and gave her a pearl set from the beautiful and remote Tuamotus.

The next morning we went to the ice cream place at Lycee Agricole and noticed that we got a flat tire. As I changed the tire Petra left my backpack on the bench and off we went. Imagine the horror to realize that same evening that the passports, boat documents, engine keys, the power cable for the outboard, wallet and the notebook with all my voyage logs were all gone. After a night of sudden anxiety attacks and a good collection of bad language we drove back up there and yes, the lady had kept the bag and returned it to us.

This voyage just got a second chance.

Now we're stuck in this anchorage because there are strong winds (30 knots) and 4-5 meter waves out. But other than that we're having a great time together and we met some interesting people, like the Spanish couple on *Talula:* Catalonian Joan Antoni and beautiful Venezuelan-born Laura, whose Catalonian father was exiled in Venezuela during the Franco era. Joan, university lecturer, publisher, and sailor also quit his well paid job and hitchhiked around the world as crew, then met Laura, a former student in one of his classes, bought a 40-footer and sailed to Senegal, Gambia, Brazil, Venezuela, Colombia, Panama, and to here. Lost and found at sea in the Med on a former Whitbread boat, gone aground in Gambia in the Delta, scared by fishermen off Brazil who were anchored in twenty meters fifty miles offshore, with no navigation lights on, only the amber of their cigarettes glowing in the tropical night. The plan is to go back to Spain in a couple of years and rob a bank to buy the Garcia sailboat. Intelligent, funny, passionate people. Joan is fifty years old, born in the same village as Salvador Dali. He says all the people there are crazy. "It's the wind, it never stops, and everybody goes crazy." Laura is 14 years younger, very well-read and deliciously funny. We spoke at length about escapism. We're all here to escape from something.

I had a feeling these two would become important in our lives, and I knew they would become our friends from the first moment I met them.

June 30, 2007

We sailed from Moorea to Huahine together with Talula. It was to be Petra's first offshore passage. It was only 80 miles but enough for her to get an idea what the ocean looks like out there. We were flying under a small jib and reefed main at 6.5 knots and Nerissa K was happy to once again make love to the sea after 5 weeks of being chained to the bottom of Opunohu Bay. We had a full moon, a sailor's best friend, the iPod was playing Café del Mar and we sailed under the stars until sunrise, when Huahine, shaped as a woman lying on her back, emerged in seven shades of blue. We could see Talula's sails turn pink in the morning light, the emerald green water inside the reef, and the beautiful mountains crashing into the sea. The coconut palms swayed golden-colored in the trade winds. On our port side Raiatea and Tahaa showed their silhouettes like two younger sisters of the same volcanic father that created the Society Islands.

The beauty of the island was overwhelming. Huahine was the only unspoiled island left in French Polynesia. There was barely any tourism and the majority of the Polynesian population there spoke no French which is truly remarkable after several hundred years of French rule.

We anchored in strong, gusty winds and launched the dinghy. Joan and Laura prepared a delicious Spanish omelet and with a bottle of white South African wine we spent the evening telling stories, always stories of people, of the sea, of voyages, of travels afar, books, films and politics.

The following day we went ashore with the cameras and filmed and photographed the stunning landscapes, the colors

and the light of Huahine. Paul Gauguin would have surely moved here if he hadn't stopped in the Marquesas.

In the afternoon we went searching for water. I was driving the dinghy along the shore when I saw an old woman in front of her hut. I waved and asked her if she had any water she could spare. She turned around and said something in Polynesian. As we pulled the dinghy on the small white beach a young boy came out and greeted us in French. He was the first generation to learn French in school. He lived with his grandmother, in poverty but with dignity. She put her heart on her chest and uttered proudly the welcome greetings in Polynesian. Her nephew was translating all this in French.

"You are welcome to our island. You can take as much water as you like. And you can tell your friends in the anchorage they can come here for water as well."

Then she ordered her nephew something with the firmness of a tall ship master. He promptly produced two coconuts, opened them with a machete and offered us the cool drinks to quench the thirst in the hot afternoon. All this time his grandmother was standing tall and proud, watching her nephews gestures closely, observing his manners, admonishing him when he was too slow for the customary hospitality.

We filled 250 liters of water and when we were preparing to leave I saw the *comptoir,* the water meter. I asked the boy if they paid their water and they said yes, but no problem, we were welcome to tell others to come for water as well. I was shocked. These people had nothing, nothing at all, except the fruit in the trees, the fish they caught and the few vegetables growing around their hut. They were dressed in rags and their hut was more or less empty, just a couple of wooden beds on a dirt floor. And yet, they were proud to be generous as Polynesians always used to be in the past.

We went to the boat and brought back a big bag of food, cans of all sorts, maple syrup, pancake mix, toast. The grandmother ordered the son away and he came back shortly

after with papayas, bananas, mangos and pamplemousse. She went inside and brought us coral and shell necklaces, she put them around our neck and kissed us. The happiness on her face was indescribable.

I hugged her one more time and she put her hands together and said:

"Maururu! Maururu!"

It meant thank you.

People go to sea for different reasons. Some have to; it's their job. They risk their lives to earn a living for themselves and for those waiting at home. Fishermen conduct the most dangerous occupation of all, and throughout centuries their sacrifice has left deep scars on coastal communities. There are and have been many widows on both sides of the Atlantic, and many church bells have rung under the heavens to bring salvation to the poor souls lost at sea. From the foggy coast of Newfoundland to Tierra del Fuego, from Spitsbergen to the Cape of Good Hope, the sea has taken its toll on the fishing community, whose denizens' courage, patience, and intimate knowledge of sea and weather, passed on from generation to generation, inspires respect and admiration.

Others seek the adventure out there. Some of these people I would call 'professional adventurers' who persuade rich corporate sponsors to fund their extraordinary feats of endurance, skill and perseverance. They are well trained, dangerously ambitious, and motivated by fame and solid cash. They help enhance the sport of sailing by testing the latest ocean technologies and by undertaking such incredible challenges as sailing non-stop, alone, around the world.

For others, like myself, the sea represents a refuge, a shelter, and a form of therapy. The sea is honest and indiscriminately fair. For some strange reason, given my non-maritime roots, it is the only place where I feel free and complete.

In what way free and complete? At sea, I gradually lose all the gravel that accumulates in my mind over time. Little by little, clarity emerges in my thoughts, distractions disappear, and ambiguity evaporates.

Places and faces and voices from the past return to my consciousness as though blown over the water from a distant continent, first forgotten but then remembered again. I am not alone, and I am not the first: sometimes out there, sailors encounter very unusual company and, to many solo sailors and explorers, the phenomenon becomes accepted reality. Joshua Slocum, more than a hundred years ago the first man ever to circumnavigate the globe, was accompanied by a bearded, pirate-like figure who steered the boat while Slocum was terribly ill. Sir Ernest Shackleton, with his phenomenal survival story from a failed voyage to Antarctica, reports the presence of a 'third man' whose protective company he and his companion secretly enjoyed during their formidable trek across the rough frozen land of South Georgia. People who skied to the North Pole experienced similar encounters.

I, myself, have many times awakened in the middle of the night with a strong feeling of human presence around me, although I was miles away from any human community. Most often I would go into the cockpit, look around the horizon and see the flickering light of a ship passing by.

I also heard a boy's quire once in the middle of an ocean, but I found out later that anti-histamines, the anti-seasickness pills are hallucinogenic.

But when I'm alone in the cockpit of my little boat, miles away from shore, I sometimes hear or even feel the physical presence of people I thought I had long since forgotten. Whether daydreaming or sleeping in my bunk, the past just keeps coming back with a vengeance. Broken phrases, a certain look, a touch, may seem to punctuate the most important chapters of one's life, as if it were an open picture album from the past. Vivid colours and sounds accompany my dreams as I, inside the shell of my boat, plunge into the waves.

The isolation that I expose myself to at sea forces me, and anyone who has done the same, to turn inwards, to really see and listen to whatever is going on deep inside. The geographical movement from A to B is a mere pretext, while it is the lesser known course of the inward journey that lures sailors, the exploration of the deepest corners of our minds and spirits that gives the final kick. It is perhaps a replay of our existences in relation to all the people we have bumped into on our erratic treks through life, in relation, ultimately, to the world around us.

July 4, 2007

Tahaa was our next stop before setting out for Bora Bora. The twenty-some mile passage from Huahine to Tahaa turned out to be rough and uncomfortable. Large cross seas and almost forty knots from the stern made for a terrifying ride that threatened to break the mast every time the sailed backed. It was almost impossible to steer. Going through the pass with this wind from the east was another adventure but we managed to get inside the reef unharmed.

That evening we had pasta onboard our boat, again with our friends from *Talula*. All of a sudden we started feeling a strong smell and as the evening progressed it got to a point where we could barely breathe. The girls covered their noses with their shirts and we wondered for an hour where on Earth was that smell coming from. As we said goodbye to our friends, who at this point were boarding their dinghy, Petra gave out a cry that there was a body in the water, stuck between the two dinghies. We switched on a flashlight and saw the decomposing cadaver of a swollen pig, floating with his four legs open, and belly up. I pushed it away with the boat hook but the current would bring it back to our boat. A bizarre, Kafka moment on Tahaa. We came to call that night "The Night of the Pig."

July 6, 2007

We parted from *Talula* the next morning but decided to meet again in Bora Bora. The trip to the allegedly most beautiful island in the world turned out to be done motoring. After four hours or so we arrived at the pass and steered for the Bora Bora Yacht Club.

I got to meet the main man at the club, an interesting character named Rapa. He was called Rapa because he was from Rapa Nui, or, as we call it, Easter Island. Rapa was a very well educated man with a sense of humor and for some reason (it may have been his 1977 tape with Nadia Comaneci in Montreal) he developed a tremendous liking for East Europeans.

"Smarta pepal, Romanians. Independent tinkers," he'd say. "Not lika sheep, lika da rest of da orld." Rapa drove us to town and told us about the big show that evening. The president of French Polynesia would be there, and some of the best dance groups in the country would be performing.

Bora Bora is the greatest tourist trap in the industry. Newlyweds pay a thousand dollars a night for accommodation there and truthfully, Bora Bora is nothing but a dusty village surrounded by a dead lagoon. There are far more beautiful islands in the Pacific but hey, it's all about aggressive marketing, right? But everything there is a fraud. The prices double when the cruise ship is in town. They have a place called "The Farm" which is another fraud. They tell people they have a real pearl farm when in fact all the shells hanging under water are dead. Except for one, the one they usually pick up from the water to show the tourists it's all real.

And on the beaches you see these white topless women with their tongues stuck down their lovers throats while locals watch in shock from the nearby road. Confusing yes, the missionaries scared the life out of the indigenous people with visions of hell and purgatory for their naked sins an now we come back with naked

women making out in public. Wouldn't you wonder yourself why the white people are so crazy?

Time to leave this place.

July 11, 2007

Dream sailing to Aitutaki in the Cook Islands. As I said to my wife, that's what the brochure promised and that's what we got. Bora Bora disappeared behind us and we had five hundred miles of open ocean ahead of us. We left the French speaking Polynesia behind and set out for Captain Cook's islands, behind that sunset and the next, and the next. Life was beautiful. We were going west again, just as I did my entire life. It's sad the Earth is round. I'd have liked to keep going west forever.

For the first time in my life I was where I ought to be. I belong here. I belong to the sea.

And for the first time in my life I was happy, truly happy.

July 15, 2007

The weather turned nasty, really nasty. Forty knots for the last two days. We hove to and waited for this miserable cold front to pass.

But still happy. Very happy. I just can't remember why.

This was a strange day. I was alone in the cockpit at night when a wave knocked the boat on her side and the mast almost touched the water. The cockpit was flooded with phosphorescent Pacific water and I was almost thrown overboard. Then the boat righted herself and as I was waiting for the water to recede through the cockpit drains I realized I had become who I had had envisioned in my dreams in Montreal the previous winter.

I had become a seaman. Man of the sea. Alone on a seemingly endless ocean. Free. I had burned the civilized mutant in me and had been reborn as a sea creature. I had forgotten everything about land.

I realized I had arrived. These were the latitudes of silence. Even the strong wind went silent. I just saw the blue foam in the moonlight once in a while, when the cloud cover would break for a moment, or a star at times, rays of light and hope in a dark universe. And the trail of sparkling blue pearls behind my princess, *Nerissa K.*

July 16, 2007

It's 2 a.m. Aitutaki is supposed to be seven miles on our port side, somewhere in the dark. I hove to in thirty knots of wind and am waiting now for daylight. Petra is below, trying to get some sleep but the motion is still very violent. We're both exhausted after the last days' rough weather. Sometimes we wonder what on earth we're doing here in the middle of the ocean, on a tiny boat thrown around like a cork.

But not today. Today we know what we're doing here. We're looking for an island.

Daylight.

Here we go. The island appeared where we expected, green and lush and beautiful. Again, smell of sweet smoke from coconut husks burning on the beach, smell of fresh bread, and human life. Scooters zooming on the road, circling the island. Two other boats approaching slowly. I got on the radio and called them. *Journey,* an American boat with our friends Larry and his son Elliot, and crew Bill and Sean. The other one was *Dreamweaver,* crewed by a Kiwi couple. Larry warned me that the electronic charts were offset by half a mile and that if we would follow the charts we would all end up on the reef! The entrance was not marked but they picked a range on shore and we could all go in, in Indian row,

in fact, more like ducks following each other inside the channel. We all got stuck several times as we dug a trench through the sand. It can still be seen from space if you use Google Earth.

We cleared in, had breakfast in the cockpit, inhaling the scent of a new island. Next to us there was a beautiful old cutter named *Pacific Spirit*. Robert Crozier came rowing to us in his graceful wooden tender and we instantly clicked. I liked the man's gentle voice and smiling eyes, his pacific spirit. He was a very thin man in his late sixties, sailing with his Argentinian wife Martha, whom he called "my girl." They had lived in Mexico on the boat for the last ten years. Robert circumnavigated the world forty years ago! He was a surfer turned sailor, messing about in boats around the world. He had a daughter and a grandson in Australia and he wanted to see them before selling the boat and retiring in a little house in the Andes.

"Maybe it's time to write that story, now that I'm too old for sailing," he said, "that story called my life."

I noticed the surf board on deck.

"We still surf, my girl and I. In fact when I go through a pass I have a hard time concentrating on navigating through. Instead I gaze at the surf crashing on both sides of the pass and I dream about surfing that perfect wave."

That night we made a fire on the beach and sat under the stars, sipping beer and talking about life. Life outside of the rat race. Life as a free being. Life as a world vagabond, a nomad soul, seeking. Somewhere in the dark we could hear drums and ukulele and the singing of Polynesian songs.

The following day, Petra and I hopped on a scooter and started riding around the island. The trade wind was warm, the sky blue, the fields green and yellow, the palms swaying on the shoreline, like Polynesian dancers gently moving from side to side. We stopped to swim in the ocean, had lunch on a beach and watched the day go by. It had been a dreamy day until the scooter refused to start, so the return to the boat was in the back of a pick-up truck. So what? Who cares when life is so good?

July 19, 2007

What is the use of a house if you haven't got a tolerable planet to put it on? (Henry David Thoreau)

Today we departed for the mysterious island of Niue. On the way out the channel we hit the coral heads and the bottom several times. Petra cried and apologized to *Nerissa K* for the beating she took. Smashing a five-ton boat on the rocks is my least favorite experience when it comes to sailing. Aitutaki was the second grounding in my fifteen years of sailing. But the boat is strong and the fiberglass-encapsulated keel can take that sort of impact.

Light wind sailing. We catch a nice dorado and we lose him three feet away from the stern. The line broke because I did not have a metal leader. I'm tired of loosing gear to this big fish out here. Time for a change of strategy.

July 24, 2007

Arrived in Niue after an uneventful passage. Just as we moored the boat, three whales came within three feet and inspected the underbody of Nerissa K. *Journey* was already there and *Dreamweaver* showed up minutes after. One of the whales went over to *Journey* and placed a fin over their deck, like a morning lazy hug. I grabbed my snorkeling gear to go diving with them but by the time I got ready they swam to the other side of the bay. Niue is one of the few totally open anchorages in the Pacific. If the wind swings to the west all boats must leave because the swell is very impressive. There is no natural harbor, just a high concrete pier onto which we lifted our dinghies by means of a crane. This is another unique system in the Pacific.

We walked up the hill to the small town and were greeted by Keith, the Kiwi Commodore of the Niue Yacht Club. He

immediately invited us for a tour of the island in his old Toyota Corolla and thus we got to hear the incredible story of Cyclone Heta's visit to Niue. He stopped the car on top of a cliff hanging 40 meters above sea level. On that unfortunate day, the wind was packing an incredible three hundred kilometer wind when a large wave appeared around the north cape of the island. A second and a third one followed. The three waves caught up with each other forming a freak wave the size of a ten story building. We were standing on a concrete foundation, a place that used to be a home. The monster wave took the entire village back to sea. Most people had been evacuated but there were still casualties and the material devastation was truly saddening. Yet these people started a long and difficult process of re-construction and recovery. The spirit of the Niuean people was evident. Friendly and welcoming, always waving and ready to help, the people of this remote Pacific island made us feel at home immediately. With a population of only 1,200 on the island it is difficult not to feel part of the family. But here are 50,000 Niueans working in New Zealand and Australia and we saw many empty, abandoned houses. The government, we were told, were running a campaign to attract some of the Niueans abroad back home.

Talula arrived a few hours later and as soon as Joan and Laura were ready we went out for a hot Indian curry and a few cold beers. The other yachties met at the club and we had a party on Finnlandia vodka and grilled sausages. Life was good in the South Pacific. *Talula* and *Nerissa K* became family and inseparable friends.

We drove our dinghies back to our boats that night and crashed in our bunks. I fell into a deep sleep, maybe it was the vodka, or maybe it was the swell rocking the boat, but around two in the morning I suddenly woke up with a sense of danger. After all these months, *Nerissa* was talking to me and I finally learned to listen and understand her signals. I quickly jumped out of my bunk and went outside. I could no longer hear the lap-lap sound made by the water slapping the underside of our dinghy, and I

knew she was gone. I must have tied a sloppy knot as I was a bit tipsy and tired, and off she went. The wind was blowing offshore and it all happened in the only open anchorage in the whole Pacific. I felt so upset I wanted to scream and shout. I couldn't believe what had just happened. I kept looking out to sea but in the moonlight the ocean looked indifferent, stone-faced. Now we were prisoners on the boat. We found ourselves in the middle of the Pacific with no place to buy a dinghy. Great!

A dinghy becomes like a pet, one learns to love and appreciate them. They offer mobility and independence, and, it seems, even loyalty. They're treasured by their owners because they represent the shuttle between boat and land. Ours was four months old, with a great little Honda engine, new as well.

In the morning, I called Keith at the club and told him about the loss of the dinghy. Joan gave us a ride to shore and Keith drove me to see a local fisherman called Brendan.

Brendan was working on the roof of his new house. After the cyclone he was left nothing but the clothes on his back and the children in his arms, as he put it. He shook my hand and asked the typical "what can I do for you, mate." I explained the embarrassment and he smiled.

"No problem, we'll go out along the coast and look for it. Usually the currents bring them back. We found a number of dinghies around here and they were alright."

He hooked up the trailer with his aluminum runabout to his truck and we drove down to the pier. An ominous squall was approaching but I was with a local fisherman, and I felt safe. The boat was only eighteen feet but he had two outboard engines and I figured we could always seek shelter with such a fast boat.

Brendan launched the boat and we took off at twenty knots along the jagged coastline. The squall hit with incredible intensity. Visibility became zero in the downpour and the wind must have been over forty knots. We got wet and cold but continued through the rough seas. Naturally, we could not see anything, so Brendan suggested we let two lines out and try our luck. It

was quite a sight to slam into those waves at high speed, the sky black, the wind whipping our faces while we towed fishing lines through a boiling ocean. And sure enough, minutes later we heard the sound of a monster pulling at the three hundred pound line. I took the wheel while Brendan rolled him in. He took a wooden bat and clobbered the fish until blood splattered everywhere in the boat. Brendan hove him inside the boat with one swift motion.

"Welcome onboard!" he said.

It was an eight foot Wahoo, the biggest fish I had ever seen on a hook. Brendan was overjoyed. He took the wheel from me and said:

"You see, I think I got lucky because I went out to help you. The law of compensation."

I liked that. All of a sudden we became friends; we had been bonded by a squall, a loss and a fish. The sun came out and the coast emerged in golden colors as a rainbow arched across the sky. But the dinghy was never to be found.

Back at the club when Brendan stopped the truck to let me off, I offered him money for the effort he had made to help me. He refused.

"You see that sticker in the back of the truck? The one with the Canadian flag? Well, sixty percent of the cost of my new house comes from donations from Canada, my friend. What goes around comes around, don't you agree?"

So here I was, on a tiny island in the middle of the Pacific, being humbled by the spirit of a man that had lost everything but his generosity. All of a sudden the loss of a dinghy did not seem that tragic anymore. I felt humbled by this man's dignity, humbled and proud of Canada at the same time. And grateful, grateful for having encountered such people in my travels. As I found out later from Keith, Brendan wanted to be known as a local fisherman but he was also the Minister of Fisheries and one of the most prominent leaders on the island.

The beauty of this island and its people will not be forgotten.

July 30, 2007

We departed from Niue today. As we sailed out of the bay together with *Talula* we filmed the island and our boats with the sails up, like butterflies between sea and sky. And we sailed west again, as boats should do, as people should always do. Keep going west. Keep chasing the sun. Three sunsets away the Kingdom of Tonga awaited us, its Vava'u group spreading from northeast to southwest like a pearl band.

Petra and I are still sad after the dinghy episode but we also realize how fortunate we are to be here together, to experience this as a couple. After a lifetime of dreams, (and trust me, I'm a professional dreamer) this voyage is truly a gift and a blessing.

The wind is picking up today and the sea is getting rough. We're moving very fast, almost too fast for comfort but I have a feeling something is coming. Something big.

Just a feeling.

July 31, 2007

The wind died. We're crawling at 2 knots. There's something in the air. Is this the calm before the storm?

The sails are flapping, the nerves are taut, and my mouth produces invectives I never heard before. Tomorrow we should see land. Today is lost. The International Date Line robbed a day out of our lives. Never mind. Time is nothing but our own invention. Tonga decided to be 13 hours ahead of UTC, or something like that. Everybody's confused about this time change. It was the King's decision. Well, so be it then. At least he left his kingdom in the southern hemisphere.

August 2, 2007

I hate to be right. We hove to eight miles from the island, awaiting daylight as usual. There was a squall that managed to avoid us, then no wind. By four in the morning the squall came back. I was a bit surprised until I realized the wind was backing. It started from southeast to east to north, backing around the clock all through the morning hours. That spelled trouble. The seas increased to eight meters and the wind was shrieking in the shrouds at forty-five knots gusting fifty. At dawn we had been blown north, more than twenty miles. The ocean started looking like a scene from the perfect storm. The lead-gray seas kept building up, crashing in the cockpit. *Nerissa K* was doing alright until that big wave swept over her and buried us under tons of green water. That wave managed to fill the genoa which was stowed on deck. Now I had a balloon over the side, a sea-anchor filled with 10 tons of water, dragging us under. Now I had a problem.

I went on deck with a knife in my hand, ready to cut the sail and free ourselves. The rigging was vibrating like the strings of a cello. Petra came on deck and suggested we try to find an opening in the sail so we could drain it of water. She's a stubborn and perseverant creature and it paid off to be that way that particular morning. We did manage to find an opening and drained the water slowly. The waves kept crashing over us. We were wet and exhausted at the end. The sail was stowed in the cockpit and we went inside and changed clothes. Hypothermia started settling in as we flew at seven knots towards Neiafu.

The landscape of Tonga was very imposing. The rugged coastline with its majestic mountains and stone-carved symbols gave us a feeling of approaching Middle Earth and after that storm our senses were heightened by the state of the sea, the wind and the threatening sky. We felt we emerged on the other side

of the planet and the storm was nothing but a curtain of time separating two worlds.

Neiafu seemed like another world. There was debris floating around the bay, docks had been broken or submerged. This was a hurricane hole and one of the most protected harbors in the Pacific and yet it had been ravaged by the storm the night before.

"How was it offshore?" the customs officer asked.

"Difficult to explain," I said. "But definitely worse than here."

I was so tired I hadn't even noticed what papers were filled and signed, but they told me I had been cleared in. We moved the boat from the customs' dock to a mooring, next to our friends on *Talula*. They had had a rough time as well, as they went west of the island and had to beat back against wind and current with all sails and full throttle. Another boat, a 50-foot C&C, broke a stay and almost lost their mast. *Nerissa K* did well and I was proud of her.

Shattered and beaten, we went to sleep for sixteen hours.

August 4, 2007

Tongans are some of the most beautiful people I have seen so far in the Pacific. I love the school uniformed children returning home, waving and smiling the most honest smile in the world. The girls have long black hair tied in rich woven tails, perfect features and fine skin. The boys are broad-shouldered and heavy-browed with intense eyes and swift body movement. Their bodies are slim and muscular, and the tapas skirts they wear actually enhance rather than diminish their manhood.

August 5, 2007

We borrowed a dinghy from the Aquarium Café sailmaker, Rick, a Kiwi in self-exile, agreed to lend us a fiberglass dinghy

so we could move around the anchorage. The dinghy is just for one person so rowing with my wife onboard is a spectacle for everyone in the bay. Rick also agreed to repair our sails which took a beating during the last few months and especially after the last storm.

I feel terribly exhausted. I think the rough passages since San Diego begin to take their toll. Petra suffered from seasickness and exhaustion herself and I had to do most everything onboard from cooking to changing sails and I feel like I hit a wall. On my first walk in Neiafu I had to stop every few meters to rest. I felt I could not drag my body uphill and the legs felt like cooked spaghetti.

So we spent most of our time at the café, surfing the Internet, eating well with our friends and listening to ambient music at sunset. Ozkan and Neil arrived there as well and we spent a few dinners together, talking about everything from the crazy world we left behind to the crazy people we met along the way.

We also met Rick Blomfield, the skipper of the C&C 50 *Mufasa* that had lost a shroud during the storm. He was delivering the boat to New Zealand where his own C&C 50 *Phantom* was waiting for him. Rick is an incredible sailor with forty years of blue water experience. We became friends almost instantly. In fact, Rick took me under his wing and gave me some great advice on approaching Fiji, something that had worried me greatly. The Fiji charts looked like a coral reef graveyard for ships but Rick showed me a few routes and calmed me down by explaining the real distances inside the channels. I admired this man for the mileage he covered, for his modest and unassuming attitude and for his honesty. I could almost see the continents he touched, the places, the people and the vast ocean reflected in his eyes. The wind had carved his face like a statue and the sun burned his skin and discolored his hair, but the light in his eyes was hypnotic, charismatic, confident and yet still searching. We decided to meet again in SavuSavu, Fiji, and he convinced me to go to New Zealand for the cyclone season.

"You can't miss one of the most beautiful countries in the world, Christian," he said.

August 8, 2007

We went to Customs and Immigration to clear out today. It turned out that I never cleared Immigration and had "overstayed" in the country. I got angry with the officer and put my hands forward for him to handcuff me and put me in jail. He was shocked.

"I lived and worked in 5 countries on two continents, officer," I said. "The worst offence I ever committed in my life was speeding a couple of times. Now, why would I break your laws when I went through so much pain to get to your beautiful Island? That day I was exhausted after the storm and when I arrived at your clearance pier there were four officers that stepped onboard. For some reason I thought both Immigration and Customs were there as is common. But go ahead, put the handcuffs on this criminal and let him rot behind bars." I don't think he expected that sort of reaction and he was taken aback and confused. The confidence the uniform usually gave him evaporated in no time.

Long story short, he did not fine me or even jail me. Later the same day I found out that the Immigration guy had had a hard drinking night the night before I arrived and his colleagues from Customs were supposed to stand in for him, which they didn't.

Never mind. Tomorrow, Fiji. Let's fly west with the trades, let's never stop, flap your wings *Nerissa* and set us free again!

August 9, 2007

Nerissa K is really flying over a tumultuous sea. We're doing over seven knots under jib alone. There are white caps and foam everywhere and the waves are impressive. I'm sitting in the cockpit

listening to a piano piece called *Bound for Tenderness of Eden* by Robert Bruce. I look at the state of the sea and am in awe. This ocean has a terrifying beauty that is simply hypnotizing. Petra is in her bunk below, horizontal. Horizontal is the only way for a seasick crew. I admire her. She's suffering in silence but she's hanging in there, keeping a good attitude and without complaining. Complaining on a boat is very destructive. I like people with a positive attitude and a tough spirit. The ocean is no place for the faint-herted, men or women. It takes patience and stamina to live inside a washing machine for days on end.

August 11, 2007

What an incredible ride! A three-day roller coaster on a rambunctious ocean. But I'm a bit nervous now. We're entering the Nanuku Passage, it's getting dark and I can't see the light at the northern edge of the reef. The radar can't see it either, it's probably awash. Maybe none of these lights are working.

Midnight. Something funny just happened. I was swearing at this invisible lighthouse when I heard a voice on the radio saying:

"I'd feel so much better if I saw that bloody light, mate!"

At first I thought I was tired and exhausted and hearing voices again but then the voice came back a few minutes later. I could not hear the other boat only this one by the name of *Finnegan*. I got on the radio and thus got to meet Sean, a single-hander from South Africa sailing in tandem with the famous Italian boat *Alice*, skippered by the infamous, larger-than-life, pirate slash anarchist slash terrorist slash Robin Hood, Senor Antonio, accompanied by his lovely African Cosa woman by the name of Hazel.

And thus, we were three boats looking for Fiji in the tropical night. After a while we said "screw it, the channel is wide so let's go for it." Sean even went to sleep for a few hours since, as he reasoned, if something would come down the channel it would

either hit *Alice* in front or *Nerissa* at the back. The next morning we would arrive in beautiful SavuSavu and recover a bit from the beating we took these past few months. Petra and I would fly back to Montreal for a few weeks and then return together with Sebastian for the last hop to the wild islands of Vanuatu. Petra did two thousand miles of blue water sailing and I was proud of her. Another chapter in this voyage had been completed and I was happy we arrived safely at this important milestone.

The morning light found us transfixed on the beauty of Fiji: majestic mountains covered in green forests, spectacular reefs, mile-long white beaches and green-blue water everywhere.

August 19, 2007

We almost lost the boat today. I woke up during the night with that feeling of danger again. *Nerissa* was speaking to me but my channels were cluttered with sleepiness and exhaustion. I went out and checked things on deck but I couldn't see anything wrong so I went back to sleep. In the morning, for some reason, I drove the dinghy in front of the boat instead of going around the stern as usual. I saw two limp lines hanging in the water. My double mooring lines were cut clean. The boat was being held in place by the quarter inch core of the second line and was about to be cut itself any minute. I told Petra to go up and start the engine immediately because we might be on the reef in a very short time. I felt the thimble with my fingers and almost cut them off too. Small shells had grown on the mooring thimble and cut the lines through. They were as sharp as surgical knives. I cleaned it with a knife and replaced the lines.

What if we had flown back to Montreal and a message would be waiting for us that *Nerissa K* was unfortunately at the bottom of the bay in SavuSavu? After seven thousand miles across the entire Pacific ocean, through some of the most reef-strewn waters in the world, and after you cared for that boat like you care for a

child, how would it feel to know you lost the boat in one of the most protected anchorages in the world, because two tiny shells decided to cut your mooring lines? Absurd!

Paranoia works: I put three thick lines on the mooring, one wrapped around the mast. People here think I'm crazy, but hey, there's no overkill when you're at sea, right?.

August 21, 2007

Montreal. Muggy, steamy, smoky, stuck in traffic. Static. Immobile. Trapped. Limbo.

I feel estranged, alienated. Can't talk to friends and family, talk about what? I ask people "so what's new?" and they all say "nothing much." Everybody's waiting for something to happen, something to come. The TV channels show exactly the same programs they showed six months ago. Nothing changed, absolutely nothing. What was I doing there? How can people live like that?

I looked at my life with outsider objectivity and was terrified. My nice house in the suburb, the proper, office slave neighbors driving their newly-leased Saabs and Jaguars, the new lawn mowers, the idle teenagers smoking pot in the backyard while their parents are at work, the false cleanliness and respectability of an upper middle-class neighborhood. The boredom, the unbelievable boredom of first world comfort. Money and comfort and the absolute boredom that comes with that. Naturally they wish for something to happen, something really bad, something dramatic something like on TV, a murder, a disaster, a plane crash or at least a fire, like in California. Everybody's envying the attention California gets: Britney Spears' hairdo every morning, the fires, the Hollywood scandals. Nothing ever happens here in Montreal. Okay, a bridge collapsed recently and there were some casualties but how can that compete with California?

So I ask again: how can people live like that? No wonder I was going insane here, in my previous life. No, I belong out there

with the wind and the waves and the stars and the Milky Way in the big southern sky, I belong to another nation of people: sailors, seekers, and adventurers. I don't belong here. I need to go back. This was a mistake.

I like the third world. I like the absence of rules, the chaos, the unpredictable, the unknown. Chaos is much more human than perfect order. I don't trust perfect order, because behind it there's always something rotten and corrupt, some big lie deceiving the masses.

August 30, 2007

Today I went out for dinner with some old friends from the corporate world. They're conspiring to bring me back, so I received diabolic offers. Power, money, BMWs, fat contracts with fat benefits. So here's the choice: a life of comfort and luxury on the one hand or a free, barefoot life in the third world?

I think I'll take the BMW.

September 23, 2007

I'm back in Fiji with my dear brother Sebastian. This morning we threw the lines off the mooring at Copra Shed Marina in Savu Savu and motored out on a windless ocean. Thank God I'm back. I would have died back home if had stayed longer. My beautiful boat is gliding along like a swan between two shades of blue, between sky and water. I'm surrounded by the great mountains of Fiji and while I'm slowly sipping from a steamy cup of the coffee I realize I am free again. As I write these words my heart leaps with joy at the realization that ahead of us there are more ocean passages, wild islands and ancient people, all waiting for us. For the next two months my brother and I would share adventures to remember a lifetime.

Back home there was more of the same. Home is here now. This is my world.

Again, the surrounding view here is truly shocking. The sea is flat, the sky is clear and all we can do is sit back and enjoy the spectacular settings. We feel like we're sailing through a *Lord of the Rings* landscape, one of those worlds with a positive vibe. Things can be perfect sometimes, rarely, I admit, but sometimes Mother Nature does like to put up a splendid show for us.

Later the same day...

Well, Mother Nature had enough of splendid shows...just as we were approaching an anchorage a mega-squall hit us with 60 knots of wind and *Nerissa K* was flattened on the water. Visibility went down to zero again so we could not see the coastline anymore. We stripped naked and took an unexpected shower as the squall passed. Then we started looking for an anchorage that was not there. There were reefs everywhere and I started getting that sick feeling in my stomach. I did not want that voyage to end there. I wanted my brother to be able to experience more than a few hours of sailing in the tropics.

I remembered Sebastian's other experience at sea, and I hoped this time things would be different. That time, on the way to Greenland, I almost lost my brother.

When I woke up that morning I saw Sebastian throwing up over the side. I could hear the violent contractions of his stomach cutting his breath, and the hoarse cough that followed. I knew then the inevitable had happened. Despite the seasickness pills, the malaise has arrived after all. I jumped out and grabbed the back straps of his life jacket as he was hanging over the rail without being clipped on deck with the tether. A large swell, five, perhaps six meters high, swayed the boat from one side to the other in a sickening motion. Thick fog

engulfed the boat and there was no visibility beyond the anchor at the bow. No wind.

Sebastian crashed on the cockpit seat after a while, green in the face, eyes injected with blood. I wondered if this was the beginning of something much worse. Somehow I had a bad feeling about this. He went below and laid in his bunk, weak and pale, his lips dry, surrounded by a white contour of bloodless skin.

'Bloody fog,' I shouted as I looked around. 'Let's hope we're out of this fog patch in a few hours.'

Then I went in and switched on the radar and the SSB radio receiver. As I waited the ninety- second warm-up on the radar unit the Halifax Coast Guard blasted shipping warning across the Labrador Sea, Grand Banks and the Gulf of St. Lawrence. As the scanner started transmitting I was shocked to see five blobs on the screen, all around us, on the 2-mile circle. My worst nightmare turned into reality. I was stuck on a windless ocean, in thick fog, with a sick and disabled crew below, in the middle of the shipping lanes, among large steel monsters ploughing the seas at 30 knots. Five ships in the middle of nowhere! Is there any place left on Earth where one can have a moment to oneself? In the middle of an ocean, we fight for the same stretch of water…what happened?

'We'll be fine mate,' I say to my brother as I stepped outside again. 'We'll be fine!'

I looked around and tried to listen carefully. I could see imaginary hull shapes coming out of the foggy darkness and run over us like enraged steel mammoths over a field of liquid lead. Yes, I could hear the engines resound through the fog particles, the air vibrating with the deep roar of thirty thousand horsepower engines.

I jumped back in and called on channel 16, warning all ships of my presence. No reply.

'Either they don't hear me, or they don't care,' I thought. 'Right, let's think.' I grabbed the horn blower from the teak box on the bulkhead and sounded it loudly in the air. Then I immediately felt ridiculous.

'Who's going to hear that?' I said aloud.

'Ooookay, the captain is a bit nervous, I admit.'

I switched the engine on and set Otto (as in Ottopilot) to work through the swell. I kept the speed at around four knots on a course parallel to the four ships left, as one had already passed astern.

I went below once again and grabbed the satellite phone. I placed a call to the Canadian Coast Guard and asked how big that "fog patch" was and if they were so kind as to notify maritime traffic that we were there and would like to live until tomorrow, if possible. I provided our exact position and they told me to stand by and wait their call back with a forecast of the alleged "fog patch." Then I called Seb's brother-in-law, Larry, in Montana. Larry is a brilliant doctor with multiple degrees and a genius in chemistry. He told me that Seb is now losing potassium; potassium a vital mineral that tells the brain to tell the body it needs water and food. Or something like that. Once the potassium is depleted, a fast deterioration of the physical and mental capacity follows, and recovery will be slow or even impossible once that critical level is reached.

'Drink pop,' he said. 'Coke, 7Up, Ginger Ale. Eat Tums. Forget about food. His body will reject it now. Go for sweet drinks, rich in potassium.'

"Thanks,' I said. 'Thanks for the advice. I'll try to make him drink something.'

Just as I was saying that my brother jumped outside and started vomiting again, only this time it was blood coming out of him and not food.

'Larry, he's vomiting blood now.'

There was no reply for a little while, then he asked how long it's been since Seb ate. I told him he had only some oats twelve hours earlier and nothing more.

'Did he continue to take the anti-histamines against seasickness?'

'Yes he did,' I replied.

'Those pills are very strong and on an empty, de-hydrated stomach they perforate anything, they work pretty much like acid. It sounds like he has a bleeding ulcers and that's not good. There are some pills

in your medical emergency pack I prepared for you. Look for the Losec box.

But if it continues for more than a few days you'll have to ask the Coast Guard to airlift him because the situation could be fatal to him.'

I hung up and helped Sebastian lie down again. In a matter of a few hours our whole situation changed dramatically. It was serious this time. The engine was loud inside and the diesel fumes did not make it better for my brother. I looked at the radar screen again and realized that three of those blobs were almost at the same position as before and I realized then that they were icebergs and not ships!

So here we were, blind, sick, tired, thrown around by a bad swell, among two ships and three large icebergs, inhaling diesel fumes and going deaf with the sound of a screaming engine. A couple of nights before, we were having wine and sea poetry.

The call from the CCG came with more bad news.

"So how big is it?' I asked.

The man paused for a second, then said:

'It's 250 nautical miles. The "fog patch" is the size of Holland.'

Initially, I got mad. Mad at the weather forecasters, at the sea, at the bloody North Atlantic, at my brother for giving me such problems, at myself for being such a fool and expose myself to those conditions instead of sailing to the Bahamas and drinking cocktails in Bimini.

But then I realized that big decisions and solid actions were required before a final disaster happens.

I had three hundred miles left to reach Newfoundland and I knew that with my brother in his state, I'd have a rough ride on my own, sleeping only minutes at a time, navigating through that fog and the many hazards inside the Gulf of St. Lawrence.

I had to turn back.

What followed was a blind race against time, a blurry memory of fog, high seas, mental exhaustion, depression, fatigue, hallucinations after four days without sleep, the strange sound of church quires

resounding again over the ocean. Then the fear I'd have to bring a dead body to shore and have to tell my sister-in-law her husband was dead because I took him on 'the adventure of a lifetime.' For four days, I did not see the sun or the sky, I did not sleep for more that a few minutes at a time, I lost electrical power for the radar and my laptop, and so had to navigate with the GPS and the charts until one hundred meters from the dock in Gaspe Marina. Remember, most of these places had been discovered by shipwrecked sailors that ended up on the unforgiving Canadian coast. After a while, I did not believe we would ever see the sun again, I thought in fact we somehow slipped into a time warp and would never return to humanity from that cold and foggy hell.

The first thing I saw after five days were the ambulance lights at the dock. Sebastian was taken away by the paramedics. I found a hotel nearby, took a shower and collapsed into a death sleep for the next eighteen hours. The fog didn't lift until a week later.

The romance had turned cold; the poetry of the sea had been stoned to death. We were defeated, ashamed, depressed, confused, lost. Alienated in a world that went on with its mundane rhythm, unawares of our loss. Everything lost all meaning, and we had to think hard to find a reason to get up every morning. People's petty problems and insignificant worries annoyed us, the comfort of civilized life disgusted us, and everyday whining enraged us.

We felt spaced, out of this world. It was bizarre, but we longed back out there. Why?

But now we were sailing in the tropics and I decided that this time everything would go well. We eventually found an anchorage further up the coast, in front of a beautiful little village called Coconut Point. Just as the sun set, Seb dropped the anchor and we settled for a starry, silent night, dreaming about the enchanted isles strewn across the vast ocean ahead of us. There were fires burning on shore and a smell of wild flowers in the air.

September 24, 2007

We woke up early today for the jump over the Bligh Water to Nananu-I-Ra, a small island north of Viti Levu, Fiji's largest island. This is where Captain Bligh sailed with a few men in an open boat after the mutiny on the *Bounty*. Throughout the Pacific I anchored in several place where Captain Cook anchored, now I was sailing in the footsteps of Captain Bligh. I'd say that's pretty good company for a sailor.

This was to be another calm day of motoring but the most interesting thing on this passage was the amount of sea life we encountered. We saw turtles, tiger sharks, two pods of dolphins, a whale and a number of terns and gannets flying around. We had constant entertainment and Seb loved it. My brother needs constant stimuli from the outside environment and I was happy he found the whole thing so exciting. He'd sit on the cockpit coaming and scan the horizon for more creatures of the deep. Then he'd stand up and shout:

"Sharks! Look over there, dolphins....a whale! Wow! Incredible!"

Just before lunch we caught a nice little tuna which turned into a delicious sashimi/sushi combination. The rice was cooked to perfection and of course we had ginger, wasabi and soy sauce in the fridge so here we were, somewhere in Fiji, sailing and having Japanese cuisine with the best view in the world.

In the afternoon we anchored in front of a beautiful beach on Nananu-I-Ra and went snorkeling. There was a very imposing building a bit inland, a resort we thought, and we wanted to ask for permission to snorkel there but there was no one around so we went in.

The underwater world is a universe of beauty, silence and at times extreme violence. That's why I like it. I like the fact that there's no talking down there. I need the silence and I despise empty talk. Second, its beauty is more graceful than the beauty

of the above-water world. Algae are dancing with the underwater currents, the coral makes architectural wonders of unmatched complexity, the colors are unreal and vivid and of course the light penetrating the surface with sharp rays gives it that warm filter through which we see a dreamworld. A feeling of euphoria and relaxation overwhelms the diver and if he goes deeper, the oxygen depletion enhances this sensation.

Third, I like the dark shadows of sharks moving underneath me. I like that moment when they look in your eyes and give you a message that you're way out of your league there. I like the shark's confidence, his elegant moves with no sign of hesitation. I like his discontent when I spear-gun a fish in front of his nose, and the fish is bleeding and he wants it but he can't get it. "This fish is mine, mister," I tell him. "You better get out of here, boy," he answers.

I like the law of the deep. There's beauty and harmony but the law of life is brutal as well. Survival of the fittest, that's what it's all about, not survival of the strongest but the fittest. The one that adapts best to the environment will survive.

When we returned to the beach, an hour or so later, Seb went to the villa to investigate who was living there. It turned out it was a private home owned by two rich Australian couples. They were on the terrace playing bridge and drinking Gin tonics. Seb apologized for using their beach but when they heard we came on a yacht they said:

"If you're yachtsmen everything on this beach is yours, mate. We're sailors ourselves."

We started the dinghy and went to the restaurant across the bay. The restaurant was empty. Empty of people and empty of staff. This happens a lot in the tropics. A sign read: "For service please go to Rob's shop."

We walked through an orchard of lemon trees, mangos, papayas and bananas and wondered if we could pick any of the low-hanging fruit. Then we came to a hut with a wooden sign: "Rob's shop." Inside a pretty Fijian girl looked shocked and

terrified to see customers. When we asked for food she looked as though we had just ruined her day. "Today?" she asked.

"No, for next Friday, if it's possible," I thought. Of course I did not tell her that. I like these people. So we coached her along the way until she agreed to cook a fish for us, providing she would find one in the village.

Then we asked her if she could give us some lemons from the trees outside the shop.

Unexpectedly she asked:

"Which one?"

"Which tree? Anyone...like that one," I said, pointing it for her.

She put her hand against her mouth and whispered shyly:

"That one is not good."

"Okay, can you bring us a couple of lemons from the good one?" asked Sebastian, smiling.

She looked somewhere towards the beach and nodded.

"Wait hia, plis."

She disappeared in the orchard and returned a minute later with three beautiful lemons in her arms. She gave us the smile of an accomplice and went back in the hut to prepare the fish.

"See how pure these people are, brother?" I said.

We sat down and looked out to *Nerissa K.* She was swinging gracefully at anchor in a postcard setting of palms, white beaches, turquoise water, red sky and pale blue mountains in the background. There were two other boats in the bay but I had anchored far from them, for safety and for privacy.

September 25, 2007

Well, last night we came close to losing the boat again. Another squall clobbered us; this was even more powerful than the one two days ago. In fact this might have been the most ferocious squall I encountered so far in the Pacific. The winds were in excess

of 50 knots, rain in buckets, visibility zero yet again. Lightning and thunder all around. I switched on the GPS and noticed with horror that we dragged two hundred meters backwards towards the reef. I stripped naked and went out on deck to assess the situation. Through the curtains of rain dumping tons of water on us, I could see we were only five meters away from the other two boats. I started the engine, Seb went forward and we reset the anchor, giving it more scope this time. I stayed awake until daylight to make sure we were not being thrown onto the reef. Very close call. We are being tested. The trials will continue.

When I asked my brother what was the most frightening thing during the storm, he said:

"Seeing you naked."

September 26, 2007

Another calm day. The sea is a large liquid mirror, disturbed only by V-shaped wake left behind *Nerissa K.* There's a big sky today with laced cirrus clouds on a blue background and it's all reflected in the water. The whole world is reflected on this ocean it seems. We make our way through the labyrinth of reefs and hope to get to Lautoka before nightfall. We met a large schooner going in the opposite direction. Except for that encounter, Fiji was all ours.

We saw an interesting islet out there, a sand patch with a few palm trees, trembling in the heat like Fata Morgana. On it there was a tent, and we envied the crazy guy that found his piece of paradise in the middle of the ocean, savoring his seclusion and solitude. Both Seb and I have a tendency to embrace escapism and we both think we could simply disappear from the world one day. That island could be an alternative for such a refuge. But before that, we have a duty to serve other people; our mission is not complete yet. We have a responsibility towards our families and towards the thousands of people that depend on our help. When

we feel we've achieved what we set out to do, well, maybe then you'll hear we just disappeared on one of those islands that don't appear on any charts.

September 27, 2007

Yesterday we arrived safely in Lautoka where we cleared in again. Today we bunkered some provisions for the trip to Vanuatu and headed out for Musket Cove, a popular last stop for yachties before they leave Fiji. The twenty miles trip to Musket Cove was supposed to be easy but again, another squall came over us and all of a sudden we had to put two reefs in the main and slalom blindly at three knots between deadly reefs, local ferries and foolish sea-doo drivers. At one point I was on deck in full storm suit and a ferry full of tourists passed right in front of our bow. The tourists looked terrified and I bet they felt sorry for the wet shadow on deck but I returned their shocked gaze with a smile and a wave of hand, reassuring them I was okay and in fact enjoying myself. Sebastian kept shaking his head, saying that I'm the craziest bastard he's ever met.

Finally we made it to the Black Rocks, at the entrance of the channel. Sebastian went at the bow to guide me through but the light was bad, it was raining and the reefs were hard to spot. Rick Blomfield warned me that the channel is a bit tricky and I felt those butterflies in my stomach again. One mistake, that's all it takes to sink a boat. Then this voyage would be over. Everything we worked for in the past year and all the sacrifice we made to make it here would be lost. The stakes are high and we simply cannot afford making any mistakes at all. That's what I kept telling myself.

Suddenly I heard my brother screaming at me to veer hard to starboard. Brown water on both sides of a marker gives me a chill through my spine. We avoid the deadly rock at the last minute and by the time we recover we're already tied to a mooring inside

Musket Cove, one of the most beautiful places in the Pacific. Hallelujah!

Not far away I saw *Mufasa*, and as soon as we launched the dinghy we went over to say hello to our good friend. That's how we also got to meet his wife Robin and son Jack. We had a drink onboard the boat and decided to meet later for a barbecue at the island bar.

September 28, 2007

I walked across Mololo Lailai and realized I had seen this island in one of my day dreams in Montreal. I felt I had been there before, if only in my imagination. There was high grass on the green slopes that melted gently into the sea. There were old trees bent by the trade winds, invisible birds singing, and a brick-red afternoon light that made me think of St. Tropez. The boats were swinging gracefully on their moorings, seemingly levitating in mid-air over a clearly visible sand bottom.

Rick showed up alone for dinner. Robin stayed on the boat with Jack, who had a bad case of sun stroke.

The large Fijian waitress had a very sharp sense of humor.

"Okay, boys, I'm the one in charge here. I'll tell you what you eat and drink tonight, and no whining, okay?"

"Yes Mom," said Sebastian. "but if I had the choice, I'd have the lamb tonight."

"That's exactly what I would have ordered for you."

And that's how it went the whole night.

"You big boys, when you go to my village, you make no babies, alright?"

She was quite something. People from the surrounding tables were all laughing. She was known as "Da Boss."

We had wine under a starry sky and the stories started to unfold. Rick seemed absent-minded and thoughtful. I asked him

how he got *Phantom* and he suddenly took us back to the seventies, as though there was something there he needed to talk about.

"I had met this gorgeous woman in the Caribbean and moved with her to Manhattan where she had her practice. Carol was a psychologist. I loved her and I was ready to do anything for that woman and I did: six years in New York without a boat. But I was slowly dying. I was a sailor, she a therapist. I could not have a yacht there, I hated Manhattan and she obviously could not leave everything and go sailing with me. Go where, to Fiji, and do what, therapy sessions on the boat?

Dead end, of course. Our relationship started to disintegrate and life became more complicated. She had a good friend, Robin, and we started seeing each other. As it became clear that Robin and I were to spend the rest of our lives together, it became imminent that Carol and I split as soon as possible. As you can imagine, guys, she would never forgive me for betraying her with her best friend, her confidante. But I was young and unhappy and life for me was miserable in that crazy city.

I bought *Phantom* and sailed away to the Caribbean. Robin joined me there and we sailed together to New Zealand. That's when I found out that Carol had been pregnant when I left and that I had a daughter with her. My own Jack was born a year later. We have now lived happily on the boat for more than thirty years."

Human stories from the warm South Pacific nights. I thought about us souls roaming the world's oceans like light particles in Universe, our destinies colliding with each other seemingly at random and yet our boats had a history, we had a history, and it all merged around a white table on a beach under the stars, with a glass of wine in front of us, memories flowing like hot red lava down the slope of a mountain of years.

"I'm fifty two now. I have to make peace with the past. So yesterday I called Carol for the first time in over twenty years. She wasn't home so I left a long message for her. "It's time for us to move on and forget the wounds of the past," I told her. "I want

my daughter to know what happened and I would like to be able to meet her. I'd like to tell her everything, how I fell in love with you, how we were happy, then unhappy, how I betrayed you, how I escaped to sea to escape my past and to build a new life. I want her to hear my side of the story as well."

Guess what? She called me back today and said, you know what, you're right; we're too old for this shit. Let's make peace. I want you to meet your daughter as well. I spoke to her about you. She doesn't want to talk to you or see you yet, but she said you can write to her. To start with.

So I wrote this twenty-six page letter to my daughter where I unloaded my soul."

He looked up at the sky and exhaled a deep breath.

"And that's the story for the night, boys."

October 1, 2007

We left this morning for Vanuatu. We were expected fifteen knots from the south-east but during the night the Fiji Meteorological Office issued a wind warning in effect for Fijian waters, which we did not know about, of course, because we left early in the morning. Thirty-five knots gusting forty. Now, that was an abrupt start for Sebastian. The seas were rough as we came out of the pass and the wind was howling in the rigging like a beast with rabies. Seb started throwing up over the side and I just couldn't believe his luck again. Every time he came near a boat, something crazy would happen. I'm a bit worried for him and I'm hoping the wind will decrease as we move away from the coast. I can't afford another health situation on the boat. So far his attitude is good, but he keeps watching the coast line behind, which means he can't yet accept the fact that he will not see land for four days.

As for myself, I was glad to be out on the ocean again. Now I can have breathing room again. I imagined little *Nerissa* as seen

from the air, a small butterfly, white wings on a big blue ocean, with two tiny dots in the cockpit, my brother and I, heading for the mysterious isles of Vanuatu, heading out for another adventure on this beautiful planet.

October 2, 2007

Seb is a little better. The wind decreased somewhat but is still stiff. We're making great progress, though. By tomorrow we should see Futuna and then Tanna. I'm forcing my brother to eat, because I don't want him to lose all energy again. But things are looking better this time around. I let him rest a lot, while I sit in the cockpit, listening to music and dreaming about living the life I was living. For the first time ever, I realized I did not want to be anywhere else, or have a different life than the one I was living. For the first time, the dream was actually reality. And I realized too, why the escape dreams had ceased to exist. It was because I did not need to beam myself out of my reality, because I was where I was meant to be, doing what I was meant to be doing. Why had it taken me forty years to get there I did not know, but I was grateful it happened at all.

October 3, 2007

LAND AHOY!
My brother is the happiest man alive. He saw land again. He smelled the smoke from the villages, and the expectation of human settlement was making him jump around with joy. Futuna was on our port side, like a tall English hat floating on the ocean, and the fuming Mt. Yasur, the Mountain of God, was dead ahead of us as we were approaching Port Resolution, Captain Cook's anchorage named so after his own ship.
"You made it brother," I said, "congratulations!"

He gave me a hug and said:
"Thank you, Captain!"

October 4, 2007

We walked up a steep path covered in black ash from the volcano on Mt. Yasur and emerged in the middle of a village left intact for hundreds of years. We saw smoke coming out of the huts and small children playing around.

A man was riding a horse on the beach. A few youths were balancing on a palm hanging over the water, while their parents were throwing nets a few meters away.

The Nafe people are some of the most beautiful people I ever encountered in the Pacific. Their features are open and their smiles honest and pure. There's nothing crooked about these people, what you see is what you get and I like that.

The village is built around the soccer field so the whole community can watch the game while they cook their food on the fire or rest under a coconut tree. There is a path covered with large flowers hanging from a tree like huge church bells of all colors making a tunnel to the Garden of Eden. The path leads to the White Beach, the most pristine beach I ever saw.

I went spear fishing at the reef with the local boys. I was a bit nervous about the crashing waves at the reef and when I asked Nelson, my new friend, if it was smart to go there, he said:

"Just go slow."

I went in and still nervous, I followed Nelson through a labyrinth of colorful coral and fish. I locked the spear-gun trigger so I didn't shoot my guide and swam slowly close to the sandy bottom. Then, all of a sudden, I saw this wave curling above the water and crashing hard on top of me. The underwater current grabbed me and flipped me over like a pancake. Nelson disappeared.

I got thrown onto a reef and started bleeding under water. Sharks, I thought, but then a strange sense of euphoria overwhelmed me. I was oxygen depleted by now but I thought I had never been more clear in my thoughts ever before, and I relaxed. All tension was gone. I realized I had never been happier ever in my life before. I was a happy man on the happiest place on Earth: Vanuatu. And I was free at last. I could not swim back against the current so I crawled on the coral, pulling myself meter by meter towards the beach.

We were worried about Nelson as we scrutinized the crashing waves in the area but after forty-five minutes we saw this black tube making its way slowly to the beach. And then, just meters away from us, he stood up like an aquatic creature, a man from the depths of the ocean, with fins and goggles and oxygen tube and all, and wearing a wire around his waist, a wire full of fish.

"Lunch for you," he said.

I guess some things should not be tried at home, but left to professionals. Nelson took me to the kastom medicine man who also had the keys to the "clinic" where I got treated with disinfectant and bandage. The clinic was an empty room with a metal bed with no mattress and a small table with disinfectant. Seb and I looked at each other and nodded. This is one thing we could do here. Then we saw the diesel generators lying idle because of maintenance problems and the high cost of fuel. We sat down on the grass with Werry, the Chief's brother and Nelson and outlined the needs of the village. We vowed to return next year with supplies for the clinic, the school, wind generators and solar panels. Our heart had been won by the village and we knew this would become our second home for the next few years.

In the evening we went up to the volcano on the Mountain of God. The power of Earth next to the power of the Ocean. Boulders were being spit out three hundred meters in the sky, liquid fire glowing in the tropical night, then the crash of solid boulders on the edge. We all went silent and watched this spectacle

of light and thunder in awe. I was sitting on the edge of an active volcano under the southern sky, surrounded by the largest ocean on the planet. This is where *Nerissa K* brought us, to the ends of the world, where it all began.

October 5, 2007

Talula and *Nerissa K* have been re-united. Our friends are here at last! *Adagio* arrived today as well. Greek-Australian Dimitri and Italian-Australian Meri were Joan's and Laura's friends since Panama so now the whole family was here to enjoy beautiful, unspoiled Vanuatu.

October 7, 2007

Another incredible day in Tanna. We went on a truck ride across the island to Lenakel, on the other side. Riding at a hundred kilometers an hour over black ash on a moonscape surrounded by a blue ocean is definitely something I did not have on my "things-to-do-before-I-die" list. There were no roads, just hills of ash over which we flew at high speed, uphill, downhill, sliding sideways, backwards sometimes, just a roller-coaster ride on top of an island in the South Pacific.

And did I mention the view?

October 8, 2007

There was an evil Frenchman on the island, it seemed. He came out of nowhere declaring he would build an airport on the island. He came with a lot of money and surely he bribed the officials to get the permit. The forest was cleared, bulldozers destroying the land day and night. On the bulldozers' tires there

was a fungus which was introduced into Tanna and which was now eating up the majestic Banyo trees which are sacred in the kastom culture.

The Frenchman hired local boys to work on clearing the bush and build the runway. One evening the Frenchman brought a bottle of Vodka. The locals cannot handle alcohol, because they don't drink to socialize, like the white man, but they rather go for the final effect of alcohol, which is getting drunk as fast as possible.

One young man killed another and left a young widow in the village. The killer's wife was pregnant with their first baby. The young man was arrested and jailed in Vila.

But in kastom things don't stop there.

Under the holy Banyon tree in Port Resolution the narkamal was called. The narkamal is the government of a village, the Supreme Court, the palace of justice, where men drinking kava with the Chief decide the fate of offenders and pass the final judgment on the matters of the village.

The narkamal decided that the killer's family should be killed, all of them, pregnant wife, parents, brothers and sisters. The decision was unanimous.

Fortunately they went for a second opinion to an old friend of the village, an Englishman who had lived there on and off for the past twenty years. His name was David.

David was obviously disturbed by the judgment but he didn't show it. He calmly said he disagreed with the verdict because according to kastom they could not apply two punishments for one crime, and since the boy had been taken to jail in Vila, they could and should not kill the rest of the family. The Chief agreed and a new judgment was passed: a peace child should be provided to replace Willie, the lost member of the village. So the pregnant girl had to give her child to the other village. He was named Willie, and thus justice had been served. A life had been replaced with another life. The new Willie would grow up in the new family and he would never return to the

neighboring village. And that's how things were settled in the kastom world.

And that's what a bottle of vodka did for a perfectly peaceful island.

October 11, 2007

Talula, *Adagio* and *Nerissa K* sailed to Erromango at the first light of day. Tanna offered a splendid show of dramatic beauty all the way across the other island. We watched the volcano, the green valleys sloping gently into the ocean, the palm forests and the taro plantations basking in the sun. There wasn't much wind so it turned out to be a lazy day of fishing, snoozing in the shade and listening to soft music under a blue sky. *Talula* went far to the east, chasing a wind which never came, but towards the afternoon we were all back together and when the breeze finally came, Joan and Laura took the lead and sailed in at Dillon's Bay under full canvas and thundering at over eight knots. We had dinner together that night, another unforgettable dinner with our friends. The conversations were flowing with the wine and again, the stories of people and places brought the world to us, sitting together in the cockpit of *Adagio*. Meri made delicious pasta and Romanian Palinka fueled the stories until late in the morning.

The next day we went and visited the school. We donated some school supplies and filmed the incredibly beautiful children. The chief took us to the rock where missionary Williams had been killed and eaten by the cannibals two hundred years ago and then we drove around the island to see a cave full of human bones. There were cracked skulls, perfect jaws and teeth, femur bones and so on. They seemed to be large individuals judging from the size of the human remains. "My ancestors," the Chief said before asking them for permission to bring us inside. "You are my brother, therefore, when you die, I eat you," the Chief said.

Seb and I are returning here next year with solar water systems and medical supplies. The agents of change are now well known in these areas. In fact, next year the villagers will have built huts for my brother and I, and this island might become our second home. The two chiefs asked us to live with them. Their island is our island now.

October 12, 2007

Port Vila, Vanuatu.

We're here. After seven months and seven thousand miles we are here, at the end of *Nerissa K's* voyage for this year. Our passage from Erromango to Vila started as an eventless, windless trip and ended with a boisterous ride across the eighty miles that separate the two islands. Seb had a hard time all along and got sick again. I let him rest all night while I sailed the boat into Vila. Despite that, we realized that we had had the best time of our lives. We spent almost two months at sea, exploring wild islands and outlining our projects for the next few years. Now, Seb would embark on the land expedition of his life: an uncharted trek to the unknown peoples of the jungles of Santo. A journey without maps. A leap of faith to a blank spot on the world charts. The fringe of humanity. The last outpost our world as we know it. This is his story.

Sebastian:

VANUATU

I am not much of a sailor... I sailed a little bit on lakes, even attempted to go to Greenland with Chris, but it was short lived as we turned around after few days due to my sea-sickness and

paranoia about the open sea. I was hoping that in this trip to Vanuatu I would avoid going blue water, but not such luck! I had to join Chris in Fiji, in Savu Savu on the beautiful Vanua Levu Island.

I fell in love with Vanua Levu right away and Savu Savu was a pearl of beauty, silence and peace. Sailing through the reef islands all the way to Musket Cove, on the other side of Fiji was the greatest sailing experience for me. No waves, green-blue water, dolphins and, most importantly, land in sight at all times. I can sail for months if I can see land and I can anchor in unknown harbors!

The morning we left Musket Cove for Vanuatu saw me in high spirits although there was a brisk wind of about 30 knots. However, within the reef there was nothing to worry about so I was optimistic. After a couple of hours, I saw the opening in the reef towards the open sea and my optimism evaporated right there... Large waves were hammering the reef and I knew we were in for a fast, bumpy ride.

It took four days to get to the first island of Tanna and 2 of those days I was sick, lying in bed like a rag, without the strength to do anything. I can degrade very quickly at sea; I don't want to eat, drink, brush my teeth or even go to the bathroom. Luckily, my brother pushed me and I had to fight the weakness and get over it. I was looking forward to land and in the fourth day, when I spotted Futuna Island I knew it was over. That day we encountered very high winds and even higher rollers, but nothing could distract me from looking for landfall. When Tanna came into view, I was ecstatic. As we turned the corner into the Port Resolution harbor, I started to smell the forest and hear the laughter of children and I was happy! I made it on the open sea and the satisfaction to come to Tanna by sea was higher than I imagined.

I was now ready to search for the Kiai people and after a week in Tanna and Erromango, we headed up north to Efate Island and then Espiritu Santo.

Espiritu Santo is the largest island in the archipelago with the highest mountains as well. Until I saw Santo from the plane, I was wondering how could remote tribes exist here. However, looking at the island from the small Twin Otter airplane, I understood: from the sea to the big mountain in the interior, the island is full of volcanic ranges, with an inclination of 60 degrees. These peaks are endless, you don't finish climbing one properly and another one arises. Covered with thick jungle, you virtually have to hold on to roots and rocks to get to the top.

Once I arrived with Werry in Lougainville, the island biggest settlement, I was impressed with the feel of this town; old, run-down buildings stood on either side of the main street, squished between the sea and the rough mountains behind. The majority of stores were Chinese-owned and a lot of colorful Vanuatu people filled the streets.

We slept that night in the Lougainville Central Motel. In the morning, before 6, Werry was already in the market inquiring of a way to get to the Kiai people. I woke up, had breakfast and headed there myself. I met Werry talking with a man dressed in *sapsapele* (traditional island dress for men). He was explaining to Werry how to get to the village of Namuro, West Santo. Then I asked him if he knows about a man called Jeffrey Karae, the guide that took National Geographic freelance journalist Zoltan Istvan into the interior of the jungle a few years back.

"Oh, yeah, Jeffrey I know, he is actually in town now" said the *sapsapele* man.

I was surprised.

"What is he doing in town?" I asked.

"He shot his wife with a spear while hunting, by mistake of course, and he brought her to the hospital!"

We jumped quickly in a cab and headed for the hospital. When we got there, I looked through an open door at the nurses' office and on a white board there was a name written: Elisabeth Karae, room 24. I pointed that to Werry and we both dashed through the corridor and knocked at 24. Jeffrey opened the door and his face seemed confused as I was sure he was not expecting any visitors that day.

I went inside and explained to him how I knew about him from reading the article in National Geographic and that I wanted him to take me as well to the Mareki people (this is the name I got from National Geographic). He listened and then politely said to me: "You have the wrong person, I am afraid, I don't know who Mareki is and I have never taken somebody there. I did take a reporter few years back to the Kiai people though." Then he went on telling me how he went there with Zoltan. Unfortunately, he would not be able to guide me there as his wife is hurt and they have a newborn baby, but he will find me some people to take me up there.

Within two hours, Jeffrey had 3 boys, Kiai people that were ready and willing to take me to their village. Tavai Isu, 25, Tavui Ateure, 23 and Shanclod Malapa, 18, were to become my close friends and the best guides into the jungle that I had in my entire life. Tavui especially sparkled my interest with his quiet demeanor and inner strength. I saw in him from the beginning a tremendous character.

We found a 4X4 vehicle to take us to Namuro village from where we would head by foot into the interior. The ride was unbelievable because we were in the back, outside and 10 minutes into the ride it started to pour very heavy rain. Within an hour we

were soaked and cold, in spite of the outside temp of 40 degrees Celsius. It continued to rain heavily for a full week!!

Once in Namuro, I changed my strategy. I got changed into a tank top, shorts and my runners. This way I did not care anymore if I was wet. I covered my cameras with garbage bags and I split the 500 pounds of gifts for the villagers among my 4 companions: Werry, Tavai, Tavui, and Shanclod. We met briefly some local villagers and children and soon we were heading through the coconut plantation up the mountain. The jungle looked steep, misty and magic. Rain was coming down in large drops, thundering and lightning everywhere and the rivers were gushing with mighty roars down the valleys. I was alone with some strangers in the middle of this vast wilderness... I have done this before in the Amazon jungles, in Africa and in the Arctic. Every single time I have the same feeling that I am witnessing a new beginning of the world, a world untouched and unknown to mankind. I forgot everything about the outside world. I was now here, in Jurassic Park and I had a tribe to discover for myself and for the rest of the world.

The hike up was gruesome; although I was carrying only my cameras, at times I could not breathe, and my heart would want to break free from my chest. Slippery rocks, muddy paths through the jungles and pouring rain made this journey almost impossible.

After 2 hours we reached the first village of Fafafia. It was empty... I found out later everyone was gone to a funeral in Malatau village. We headed to Malatau where we spent half an hour catching our breath. Then up the mountain to Supemalau, where the chief's wife asked us to stay for a meal, but we refused. From Supemalau up even more to Charafalifu, Morukari, Tapunpotari and then finally Marakai. By the time I got there, I did not know what my name was anymore. My skin was wrinkled

from top to bottom from wetness and humidity, my cameras shut down from humidity, everything I owned or had for gifts completely wet... I was broken down, exhausted and extremely thirsty and hungry. The chief met us with a smile and all his children came together for a photo. They immediately provided a hut for my disposal where I crashed with my guides for rest and nourishment.

That whole night the wind pounded, there was lightning and thundering and around 5 in the morning we had an earthquake as well. I wondered how this hut survived so many storms, hurricanes, earthquakes... Outside the trees were beaten by the fierce winds, but inside the hut there was silence and peace.

I woke up in the morning with the smell of smoke and wet wood. The boys were already up and were making the fire to continue drying our clothes and equipment. My video camera was in pieces all over the floor in my attempt to dry it. Humidity made it impossible to film. It happened to me before in the Amazon among the cannibals of the Carib tribe. Right in the middle of some of the most intense experiences of my life, I see C-21 flashing on the LCD screen of my camera. I learned to loath the sight of that code. (C-21 means humidity due to condensation)!

I am almost poisoned with that smoke. The huts have no windows and the doors are shut due to the storm outside. I don't know how these people and their children live in here every day... After a small breakfast of corned hash and biscuits, I went outside trying to capture on my Nikon D200 camera some photos. I have to have at least some record of these people and my passing here. Otherwise, nobody will believe.

In the chief's hut, the ladies gathered together to prepare a feast for me. Tavui and Tavi, the chief's two sons, went hunting this morning and came back with a wild chicken. Tavui dropped

the bird on the coals as it was, burned the feathers and then the girls started to pick at it and prepare it for lunch. An enormous amount of taro root is being cleaned and put on hot rocks in the fire. Casava, coconut milk, wild cabbage and pawpaws are also part of the feast. It takes a whole day for the feast to be ready and around 5 we sit down to eat. Everybody eats together and dips his fingers in the same bowl. I am now part of the tribe, because once they share with you, you become one of them. Eating together in these tribes is the highest honor. I sit on the floor of the chief's hut with all his family and I am eating his food. 10 hours ago he had no idea I existed on this planet, had no clue somebody like me would come across his village and had no idea what intentions I had. Now, as we are eating, I tell him that I am a missionary and I came here to see how I could help. Do they have any needs? What would be the biggest and most stringent of them?

The chief looks at me, then at Werry who is translating and in a normal tone, as if he did not hear me, starts telling me that his hut survived 4 cyclones (hurricanes). He built it 20 years ago himself out of bamboo poles and palm leaves. I thought to myself, he should go to Florida and teach those guys how to build houses to stand hurricanes. He tells me that some other white people passed by here in the past but came, ate, and then they left without any intention to help the dwindling down tribe. He then looked at me, straight in my eyes and said: "When you walked into my villages yesterday, wet and tired, I knew you were not a tourist. I saw in your eyes that you came led by your heart." Then he told me that a third of their children are dying of malaria and dengue fever, that the water is poisonous all around and they have to go far away to a mountain stream and carry a little bit at a time to drink at the village. He said that their tribe, the Kiai people is dying and the outside world does not even know that they exist. "The mountains are steep here, the jungle thick and the white man is afraid to come so far inside to help us." There are no roads,

you cannot drive a truck and bring supplies, and everything has to be carried on the backs of the local people here.

I noted his passion for his people and decided to help them out. The challenge is great but somehow a way to help tribes like this always came around. That is why my endeavors around the world were called a work of faith, because we do not always see how we can do it, but it always becomes a reality.

I spent the rest of the week from village to village climbing up and down those steep mountains and I experienced the tribe and their problems in a deeper way.

Werry and I left the interior of Santo in a tremendous storm; the streams that we crossed when we started were now waterfalls and rivers. We had to navigate through swamps, caves, broken trees, gushing waters. I lost my satellite phone, all my clothes were gone from my bags being smashed against the rocks and I was soaked. Reaching closer to the Namuro village, I got very thirsty. In spite of water all around I could not drink anything. I told Tavui if there is any way we can get water here and he said that we could drink the green coconut water. I looked around, and all the coconut trees were between 25 and 30 meters tall with branches only at the top. I said to myself: "Would be nice to have a ladder now." Suddenly I saw Tavui with the machete in his mouth friction-climbing those trees like they were nothing. Once he reached the top he cut a massive branch with about 6 coconuts on it. He cut it with a single hit! He threw the machete down and we went to pick the coconuts. Just then we saw a huge rat, some kind of rodent that lives in the coconut trees and feeds off the flesh of the green coconuts. It must have been hiding in the leaves up in the trees to stay away from the pouring rain. Once it touched the puddles underneath, it quickly jumped back onto the same tree he came from. I started to shout at Tavui to be careful because this thing was big and intent on climbing his

tree. Tavui looked at it and for a second pondered what to do. I would have jumped from the tree and most probable would have broken my legs. But Tavui grew up in the jungle and he was not going to jump. As soon as the rat came within reaching distance, Tavui threw himself out in a rotating movement around the tree. He was hanging on with his hands only. He made a 360-degree turn on his hands around the trunk and came right on top of the rat and crushed its skull with both his feet. The rodent fell dead at our feet and then Tavui very casually climbed down, picked up a coconut and with one motion sliced it at the top and gave it to me to drink. I quickly drank and thanked him too. I did not want to upset him at this stage. I knew what he was capable of.

When we got to the road we found out that the rivers swept the whole bridge and no cars were going over. We crossed somewhere upriver, back in to the jungle and then we reach the village of Wailapa where Tavai's brother took us in his 1966 pick-up truck back to Lougainville.

As I entered the Aore resort, the small island resort across from Lougainville, the locals at the bar were waiting for tourists from Australia and NZ with leys of flowers to hang around their necks. When Werry and I appeared there, wet, muddy, with torn clothes and unshaven for the past week, everybody froze. They made the attempt to be nice and polite and tried to hang the leys around my neck but I only looked at the small Australian lady that was the manager there and I said: "Do you think this is what I need now?"

Everybody was dressed nicely, drinking tropical shakes, enjoying the peaceful surroundings of the Aore Island. They had no idea we came from the end of the world, but for some reason, I did not want to share that with anybody yet. It was my secret, and I looked at Werry as we headed to our room and we both smiled.

We felt a deep satisfaction that we contacted a tribe that lives in 9th century BC and ate with them and slept in their huts.

I will return to the Kiai people... we need to install water systems, filtration devices and purification systems that will give them more water. 10.000 mosquito nets will fill Vanuatu villages to protect their children from malaria and dengue fever. Students from my school in Romania will come and train young people in their villages and stand with them as they face the new challenges of their life.

It is hard to explain to people why I do what I do... However, as time passes and my experience broadens, I realize that I need to explain myself less and less. People that have never experienced a remote tribe in its own setting and lifestyle, that have never been through the toil of exploring new places and new cultures, may never fully comprehend what this is all about.

After a decade and a half of living with remote tribes from Congo to the Arctic, from the Amazon to the Kalahari and South Pacific, this is who I actually am, who I actually became. I am the voice in the wilderness, reaching to the farthest corners of our planet.

November 15, 2007

Letter from our friends on Adagio:
Dear Sebastian and Christian, g'day from the land down under.
Finally made it home and so happy to be here. How's Canada, I heard a rumour that it's cold up there. The temperature here is about 22 degrees and we're sitting on the boat wearing long pants, jumpers and socks. How would we ever survive Canada? The trip was very good and easy except for our friend Bill on Aquantique

who sailed with us, miscalculated a 25 mile wide passage between Huon Island and the top of New Cal, and ended up on a reef. He lost the boat and was airlifted by a helicopter to Noumea. We're still in shock. Imagine what he must be feeling after cruising for 5 years without a mishap and so close to home. Always pays to double check co-ordinates. Anyway it's going to be a long journey making the transition from a fairly free boat life to becoming responsible people (what are we thinking).

We are moored upriver in the heart of town, about 12km from the Burnett River mouth. $280/month live-aboard with showers and laundry in the small marina &180/month storage. They are 2 point moorings (fore and aft) and very strong.

Have a 5knot current to contend with but hey! we are safe and sound, which is more than I can say for our friend Bill who left Vanuatu with us.

The morning we left he was having problems with his chart plotter saying that waypoints he was given didn't match the charts and one waypoint seemed too far south, in fact put him on a reef. Well he decided to trust the chart-plotter and ended up on a reef north of Noumea (northern tip of the south side of Grand Passage). We got the mayday call at 0700 during the rally net. He hit the reef about 0400, his rigging broke and the mast came down and anchored him to the reef. Meri and I turned back since we were only 10 miles away. We were able to stand off the reef by 1/4 mile and keep an eye on him but couldn't launch our dinghy because it was too rough. A rescue helicopter came a few hours later and he was airlifted to safety. What a nightmare. After that we were so stressed through the trip checking and rechecking our charts.

Anyway all is well now and he's in Sydney with his daughter, but the boat was a write-off.

Personally we think he trusted other's waypoints (which were wrong), didn't consult his paper chart (which photocopied and was accurate), was too fatigued (had 2 horrible passages prior),

and probably fell asleep (solo sailor). The passage is 20 miles wide and you could drive a tanker through it. Our charts, both digital and paper, were spot on. Worst feeling of my sailing days, watching a friend's boat being pounded for 6 hours whilst waiting for a chopper. The best way for us to get him off would have been for Bill to jump overboard with his life vest and flotation device and drift down to us. A life-raft would, probably have snagged on the reef. Below is a letter we received after his safe arrival in Noumea.

LETTER FROM BILL ON AQUANTIQUE;

Hi Dimitrious & Meri.

I wish to thank you both for the tremendous effort in navigation which you did to come to my assistance, and to standby until my departure. It was a very sad time for me and I am still in shock.

I arrived in Noumea about 3pm and after clearing customs and police I was invited to be the guest of Club Nautique Caledonia. I have received wonderful assistance from the CNC in Noumea, who provided a hotel for 2 nights, plus meals, beer, office staff, communications etc.

I am safe and well, although I still have day/nightmares hearing the crunching noise of hull over coral, and am still in shock over abandoning my only home. The incidence started at 4am in the dark, so I had no way of seeing the extent of the reef. After struggling for about 1 hour I was able to escape and head towards east which I thought was safety (wrong). I had some light by then and was sailing in 40m of water. I could delineate reef only by breakers. I should have hove-to until better light. Then

I hit the 2nd reef and over went the mast and sails. The boat was rolling heavily as you know. Although I still had motor and fuel, I did not know a way out of the reef, and my communication was probably of limited time. I was in a remote area. My choice to abandon Aquantique was a hard one, but at low tide & those seas she would probably disintegrate within a day or two. To get a tow out would take longer. Besides, the damage to the underside must have been great and I was lucky no holes appeared. I had time to pack bags of essential clothing and personal items, but of course many valuable items were left behind. The cost of recovery and repairs is way beyond the value of the boat of 1982 vintage.

I believe you were using C-Map4 CD charts on your PC. I have those and I have since discovered they are very accurate for the area. Unfortunately, I did not double check my WP's with those charts. I was using a chart plotter with C-Map NT+, # M-PC-C204-06, dated 13/2/06; this covers the South Pacific Islands from French Polynesia to New Caledonia inc. This chart showed the detail of Huon Island and anchorage to the north, so I assumed it was accurate for the Grand Passage. I selected a WP in the centre of the Passage - this turned out to be the reef at the top extremity of Recife de Cook. I have since learned from CNC of two other similar accidents in recent years using the same charts. Maybe you can help in warning others of this problem.

I shall return to my daughters in Sydney within the next few days. Then to start a new life and a new home; where - I'm not sure. But I expect to be back on the Sunshine Coast or further north & hope to meet up with you sometime. I will stay in touch. Again, many many thanks. Bill Morton.

Anyway say hi to your families for us even though they have no idea who we are and a very merry xmas in case we forget to tell you later. Yiasou, ciao love from us. Maybe we'll see you again one day. Meri and Dimitri

"We shall not cease from exploration
And the end of all our exploring
Will be to arrive where we started
And know the place for the first time."
--T.S. Eliot

It is December again. A few snow-flakes cover the tree branches outside my window and two logs are crackling in the fire. It is dark now, lest the orange light of the fire dancing on the walls and a thick yellow candle on my desk.

A year ago I was sitting at this table writing the beginning of a dream, a voyage that at the time was only a blurry vision in my mind.

Did this voyage really happen? The clearance papers from all those remote ports seem to indicate that: Taiohae, Nuku Hive, Papeete, Tahiti, Niue, Cook Islands, Tonga, Fiji, Vanuatu. Have I really been there with my beautiful little sloop, across all those thousands of miles of ocean, through all the uncharted reefs and volcanoes, across the Equator and through the entire southern hemisphere? Or was this just another one of my time-spastic travels of my own imagination? The hair is long now, the skin is sun-burnt and wind-beaten and there are scars on my body testifying of encounters with coral heads and jungle bush. Despite the evidence I have a hard time believing it myself.

But what I know for sure is that I have learned so much, about myself, about that beautiful world out there, about people, about life as is. Yes, I'll keep going back 'til the end of my days, back to the South Pacific, chasing the sun westwards, following my legend, dissolving in that great beyond, being a grain of sand, a vagabond. A vagabond of the sea.

I finally found peace in my heart. My wife is standing behind me, reading this, and we both remember the sunny days under sail as we made our way from one island to the other. She hugs me and gives out a nostalgic sigh. It's difficult not to be emotional. This

has been a year of courage and love, of daring dreams, of precious time spent with the people I love across a vast ocean. This ocean separates my old life from my new one now and I like my new existence. The curtain of time opened a new space in my life and I'm looking forward to step in and embrace this new adventure.

As I said earlier, there was no beginning and there would be no ending to this story. Next year we will be back in Vanuatu, before heading down to New Zealand, the next great chapter in this story. And then, who knows, on to Asia, India, Africa and then west again, to more hazy shores and foreign lands, to more ancient cultures and mysterious peoples and on to the next unknown island beyond that horizon. For as long as the world will turn, and for as long as we breathe, we shall sail the seas in search for our souls, and to be saved.

WINTER IN THE WAITING ROOM

December 27, 2007

I'm reading Steinbeck's "A Life of Letters" in front of the fire. There's a snowstorm outside and the house is trembling in the wind.

51 years ago Steinbeck amused himself by dashing off a letter to James Pope and a commencement address for him to deliver at Emory University. It went like this:

Advice to a new generation

"I suppose you think I'm going to give you one of those 'You are going out in the world' speeches. (Laughter and cries of 'Hear, Hear.')

"Well, you are perfectly right. You are going out into the world and it is a mess, a frightened, neurotic, gibbering mess. And there isn't anyone out there to help you because all the people who are already out there are in a worse state than you are, because they have been there longer and a good number of them have given up.

"Yes, my young friends, you are going to take your bright and shining faces into a jungle, but a jungle where all the animals are insane. You are going from delinquency to desuetude without even an interlude of healthy vice. You haven't the strength for vice. That takes energy and all the energy of this time is needed for fear. That takes energy too. And what energy is left over is needed for running down the rabbit holes of hatred, to avoid thought. The rich hate the poor and taxes. The young hate the draft. The Democrats hate the Republicans and everybody hates the Russians. Children are shooting their parents and parents are drowning their children when they think they can get away with it. No one can plan one day ahead because all certainties are gone. War is now generally admitted to be not only unwinnable but actually suicidal and so we think of war and plan for war, and design war and drain our nations of every extra penny of treasure to make the weapons which we admit will destroy us. Generals argue with Secretaries about how much they've got and how much we've got to fight the war that is admitted will be the end of all of us.

"And meanwhile there is no money for the dams and the schools and the highways and the housing and the streets for our clotted and festering traffic. That's what you are going out to. Going out? Hell you've been in it for years. And you have to scrape the bottom to avoid thinking.....

"Let's face it. We are using this war and this rumor of war to avoid thought. But if you work very hard and are lucky and have a good tax-man, then when you are fifty, if your heart permits, you and your sagging wife can make a tired and bored but first class trip to Europe to stare at the works of dead people who were not afraid. But you won't see it. You'll be too anxious to get home to your worrying. You'll want to get your blown prostate home in time for your thrombosis. The only exciting thing you can look forward to is a heart attack. And while you have been in Athens on the Acropolis not seeing the Parthenon, you have missed two murders and the nasty divorce of two people you do not know and are not likely to, but you hate to miss it.

"These are you lives, my darlings, if you avoid cancer, plane crashes and automobile accidents. Your lives! Love? A nervous ejaculation while drunk. Romance? An attempt to be mentioned in a column for having accompanied the Carrot Queen to a slaughter house. Fun? Electric canes at a convention. Art? A deep seated wish to crash the Book-of-the-Month-Club. Sport? A television set and a bottle of the proper beer. Ambition? A new automobile every year. Work? A slot in the corporate chain of command. Religion? A private verbal contract with a Deity you don't believe in and a public front pew in your superior's church. Children? Maybe a psychiatrist can keep them out of the detention home.

"Am I boring you, you nervous sons of bitches?"

Thursday, January 3, 2008

I wake up at about seven every morning. I shower, I put my contacts on, get dressed and go downstairs to make coffee. A St. Viateur bagel goes into the toaster while I prepare some smoked

cheese (Swiss Ementaler sometimes), butter and Kalles Swedish caviar, my favorite. Orange juice in a tall, heavy glass with wide opening at the mouth. I watch the news on CBC while eating my bagel. Then I take my coffee with milk in a large yellow mug and move to my writing table where I listen to literary podcasts from New York Times, the New Yorker and CBC radio on my MacBook Pro. The podcasts are mostly on art, book reviews, fiction, journalism and news. This usually takes about half an hour. By eight thirty I'm awake enough to think and so am ready to warm up my fingers on the keyboard by answering e-mails and writing in my journal. Ten o'clock I open the manuscript file containing my new book and write uninterrupted until about four thirty or five. At five I go on the bike and ride at high-tempo non-stop for thirty minutes while listening to house and trance music. This is my brain-resetting time. Shower again and dinner by six. Possibly an argument with my son at the dinner table.

Then I play music and read until midnight in front of the fire. I often read two or three books at a time, mixing fiction with non-fiction to stay sane. From midnight on I try to still my mind for an hour or two before I can sleep. That's about it.

Sometimes I watch movies. Sometimes I have friends over for dinner. Sometimes I take a long walk with my wife.

But most of my time is spent in solitude and silence, writing and living in my mind. And I love it.

Voila. C'est ma vie.

Tuesday, January 8, 2008

Today, more snow and a poem:

In the harbor of my mind

In the harbor of my mind

Nameless ships come and go

They bring spices and jewels

Rats and trash

And occasionally a good idea

In the harbor of my mind there

Are worlds that don't exist

People I don't know

Sounds I never heard before

And occasionally a kiss

From a woman in the harbor

Of my mind I receive a smile

A kiss blown from a young palm

Through the swaying palms

And occasionally blue sea

Wind is blowing through

The harbor of my mind

And a butterfly struggles

Across an empty sky

And occasionally white puffy cloud

Friday, January 25, 2008

I feel that anger in me again. I'm stuck in this waiting room and it seems most of our lives are spent waiting. Waiting to finish school, waiting for a vacation, waiting for winter to pass, waiting for visas, waiting in the airports, waiting in lines...waiting for "the right time."

Just think how many duplicate days we have in our lives. How many days have you lived that were an exact copy of the day before and the day before? Well, I have a problem with that. It makes me angry and this rage inside me spills over to the people around me, and I become mean and moody and just waiting for a reason to explode. Waiting again.

I feel like a pressure cooker, whistling desperately and on the verging of blowing up the top. Because I find it very sad that we do so little in our lives because because of all this waiting.

We work eleven and a half months a year, waiting for one or two weeks of time off, then we go back to the grind for another year, then we're prisoners of this northern climate which reduces further our lives. No, something is wrong here. This is not a

good deal. We're being scammed I think. This is not how it was supposed to be. If we were born free, we should be allowed to live free. Now winter becomes the personification of an oppressive system.

I suggest a revolution. People of the north, drop everything you're doing, get in your cars, hop on a train or an airplane, or take a boat and go south. It doesn't pay to be stubborn here. Let's all go south and forget about this nonsense. Let us free ourselves.

Tuesday, March 21, 2008

Henry D. Thoreau wrote a million words in his journal.

"My journal is that of me which would else spill over and run to waste, gleanings from the field which in action I reap."

March 21, 1840, 168 years ago to the day, Thoreau wrote this:

"The world is a fit theater to-day in which any part may be acted. There is this moment proposed to me every kind of life that men lead anywhere, or that imagination can paint. By another spring I may be a mail-carrier in Peru, or a South African planter, or a Siberian exile, or a Greenland whaler, or a settler on the Columbia River, or a Canton merchant, or a soldier in Florida, or a mackerel-fisher off Cape sable, or a Robinson Crusoe in the Pacific, or a silent navigator of any sea. So wide is the choice of parts, what a pity if the part of Hamlet be left out!

I am freer than any planet; no complaint reaches round the world. I can move away from public opinion, from government, from religion, from education, from society.

. . .

These are but few of my chances, and how many more things may I do with which there are none to be compared!"

Thursday, April 21, 2008

I just got back from a road trip through the U.S. and am more pessimistic than ever. We drove through depressed Louisiana, Alabama, Mississippi, a little nicer Florida, even better South and North Carolinas, Georgia, D.C., New Jersey and New York. Crumbling, ugly cities, poverty and decay. Horrible hotels (Holiday Inn, Mariott, Hilton) terrible TV channels, weird people, obese and deformed creatures, and of course, a threatening police force in a police state. In Washington we saw mostly police vehicles, armored trucks and snipers in trees, waiting for orders to kill. On the highway, convoys of military equipment, tanks and humvees. A nation on the warpath, obsessed with weapons, tense, confused and divided. TV evangelism and manic-depressive commerce. Bad food and ignorance.

This is probably the last time I will ever travel to the U.S. unless I have to. The Third World looks increasingly appealing.

Sunday, July 15, 2008

Of deserts and memories:
Borge's 1929 poem speaks of the romantic notion of a frontier town:

A cigar store perfumed the desert like a rose.
The afternoon had established its yesterdays,
And men took together an illusory past.
Only one thing was missing - the street had no other side.

It reminded me of the thrill of walking through a desert town lost on the shores of Africa and becoming aware of the settler history in that remoteness, at the end of the world...I saw the ships coming in, the tenders lowered, people and coffers loaded and the few thin silhouettes landing on the beach, women holding on to their hats in the fresh breeze, men waist deep in water, gazing at a new continent, envisioning a new life.

BACK TO THE MOTHER SHIP

Port Vila, Vanuatu, August 2008

I'm in the cockpit of my boat listening to Spanish monks singing in Latin. It's seven in the evening and the anchorage is calm and quiet.

I'm alone and will be for the next one hundred days. It's an interesting time, living in Port Vila and inside my mind.

So I'll be keeping a journal. Let's see how it goes.

Well, at the moment it's not really going that well. Words don't come easy and nothing is the same this year. Petra and I arrived here five weeks ago. The boat looked like an abandoned child, filthy, neglected and hungry. Hungry for the ocean that was just a few feet away from the cradle that imprisoned her. Pretty much everything stopped working. We worked madly for twelve days to get her ready for sea.

But there were other boats there, hurt, badly hurt. Two of them were sunk and salvaged, turning dreams into nightmares. Boatyards are dreary places. People move out; rats and cockroaches move in and destroy the yachts systematically.

I was relieved to finally see Nerissa K back in her element, floating graciously, clean and well dressed in white sails. We set out north towards Espiritu Santo and it was beautiful to see her

make love to the sea again, the bow wave frothing at her mouth like a sensual, bubbly glass of champagne, celebrating freedom. A day and a half later we dropped the anchor in Luganville. My father and my sister-in-law were on the beach, waiting for us. Sebastian was up in the mountains, with the Kiai.

We spent a lazy week on Aore Island, snorkelling, going for long walks, eating lavish dinners under a full moon.

But nothing was the same anymore. I could not reconnect and I wasn't really interested in the cruising part any more. I felt like I was on a delivery job, I was there just to transport a boat to New Zealand. The magic was gone. What had changed? Where did my motivation vanish?

Perhaps it was the thought of being trapped here for three months of solitude. Perhaps I no longer enjoyed the solitude but rather realized something new about myself: that I actually needed other people around me and that maybe I wasn't the lone wolf I thought I was. When I say solitude I don't mean absolute solitude. There are people in Vila, sailors, locals, tourists, missionaries, businessmen, fortune hunters, pirates. Men, women, children.

Yet I dreaded the coming months because I knew I'd feel very lonely. Maybe it's a sign of age. Maybe I was getting soft. Who knows, maybe I realized I was most lonely amongst big crowds.

We sailed back to Vila. One calm evening I caught the most beautiful fish I had ever seen, a rainbow-coloured mahi-mahi, about a meter long. He was dancing on his tail above water, ripping at the line wildly. I brought him right next to the boat, so close that I could touch him. He fought ferociously for his life and I respected him for that. Ocean fishing means that you have to look your fish in the eyes before you kill him. They're powerful, smart and stubborn. They fight all the way till the end, and the final battle is the most violent one. Some sailors got seriously injured. Some even disappeared at sea after being pulled overboard, trying to get their catch out of the water.

My fish relaxed for a few seconds and instinctively I lifted him out of the water. I lifted him in the air and when he was free he

arched with such force that left me in a state of shock. I was in awe at his determination to live.

He broke the steel lead and plunged back into the ocean. I thought he looked at me for a second before disappearing.

I cried for an hour after that. It is one of the greatest emotions I have ever experienced, a mix between loss and triumph, bitterness and joy.

My fish. I hope he lives on to teach the young ones what survival means. He certainly taught me a lesson.

August 27, 2009

I don't know what it was but it hit me hard. I fell sick for five days and did not leave the boat once. I lost a lot of weight, and I felt weak and depressed. In between delirious spells at the height of the fever and mint teas with honey, I read *1421, The Year China Discovered the World*.

As soon as I got better I was invited onboard *Moonfleet* for dinner. Alan and Diane prepared an exquisite sushi on their elegant yacht and we talked much about books, navigators, writers. John of *Camissa* was there as well. Alan and Diane are British and John is a kiwi. I read to them an excerpt from one of Theroux's travel books in which he describes the English as archaic:

"Once, from behind a closed door, I heard an Englishwoman exclaim with real pleasure, "They are funny, the Yanks! And I crept away and laughed to think that an English person was saying such a thing. And I thought:

They wallpaper their ceilings! They put little knitted bobble hats on their soft-boiled eggs to keep them warm! They don't give you bags in supermarkets! They say sorry when you step on their toes! Their government makes them get a hundred-dollar license every year for watching television! They issue driver's licenses for thirty or forty years – mine expires in the year 2011! They charge you for matches when you buy cigarettes! They smoke on buses! They drive on the left!

They spy for the Russians! They say "nigger" and "Jewboy" without flinching! They call their houses Holmleigh and Sparrow View! They sunbathe in their underwear! They don't say "You're welcome"! They still have milk bottles and milkmen, and junk dealers with horse-drawn wagons! They love candy and Lucozade and leftovers called bubble-and-sqeak! They live in Barking and Dorking and Shellow Bowels! They have amazing names, like Mr. Eatwell and Lady Inkpen and Major Twaddle and Miss Tosh! And they think we're funny?"

I went on Skype afterwards and talked with Petra and Sebastian but I felt weak again and a bit depressed at the prospect of being stuck in Vila for such a long time. I'm sure many readers would say it's not such a bad thing to be stuck on a tropical island but as I mentioned earlier, this year things were different and I could not find my pace again. I was out of sync with that world and I was too worried to be able to enjoy it. I was worried about a fuzzy future, the prospect that I'm running out of money in paradise without a clue as to what to do next. I knew I had to stick to traveling and writing but it was a fact that the writing would not feed my family for long. In any case I was determined not to return to some office and waste my life promoting useless products that no one needs. I just wanted to sail on, forever. And write about it all, write for myself if not for anybody else. But that might mean a life of poverty and I was afraid to be poor again. Contrary to the popular belief, poverty amputates the spirit. The poets, the great writers, the musicians of significance, none of them wanted or needed to be poor in order to create, they just did not have any other options. But give an artist the financial means and you will see the style and extravagance they will surround themselves and live their life in. Because the artist sees his life as an art form as well. Only a poor, dry soul would prefer to eat a cold sandwich in the backyard of a suburban bungalow.

I had questions. I had doubts about the whole thing called life. It's difficult to make any sense of it. One is thrown around left and right, as though caught in the undertow of a tsunami,

and one never knows where one would end up, usually in the strangest of places.

What was I doing there, alone on a small boat, in a place that most people cannot find on a map or even heard of ever before?

What was I doing there?

September 6, 2008

I flew to Erromango a few days ago and it was quite a remarkable experience. In fact I don't think I will ever forget it because it was reminiscent of Maugham's *South Sea Tales*. I was happy to have discovered these strong characters that would eventually end up in some of my stories in the future. I flew there on behalf of my brother who wanted me to investigate the results of his sponsoring a water system on the island. That turned into a disaster, but for a writer, Erromango was a goldmine.

I travelled to Erromango twice. First time I sailed there a year ago with my brother onboard *Nerissa K*. We anchored in Dillon's Bay and soon after were greeted by local canoes wishing to trade with us. That's how we got to know Jason Mete, Chief William Mete's son of Umpongkor. He took us around the village, showed us the school where 200 children learned about the world in both French and English, the local gardens of island cabbage, taro and manioc.

The second time I reached the island was by Twin Otter from Port Vila.

I was the only white onboard and as I was to find out later the only white on the island for the few days I spent there. The plane was half-full of cargo, the remaining eight seats filled with sick children returning with their mothers and grandmothers from the hospital in Vila. They were all coughing, spitting phlegm and vomiting in the specially designed paper bags. The ocean below looked like the mirror image of the cirrus sky above us, veiled with white caps and lacy streaks of foam blown by the strong trades.

It had been a bumpy ride and the landing on the rough airstrip was unnerving as we skidded across high grass and scrub. Jason opened the airplane door and greeted me with a nod and half a smile. That was all. With him was his nose-running son George, named after George Bush and in honor of the invasion of Iraq.

We jumped in the back of a truck and drove down the mountain at spectacular angles. Accacia trees and guavas flanked the road. There was an aroma in the air that was hard to identify, but there were mandarin trees, frangipani, bougainvillea, hibiscus and lime trees, and their blended scent wafting into the golden afternoon. Time stood still on that island; in fact, literally speaking I don't think there was one ticking clock in any of the five villages scattered along the coast.

I was thirsty and when I signaled to Jason he banged the side of the truck until it stopped, then a young boy climbed a coconut tree with a machete between his teeth and soon after we heard the coconuts hit the ground with a thump. Jason took the machete from the boy, opened the coconut and then cut a round scoop from its green skin.

"Spoon," he said.

We sat on the high grass covering the plateau and drank the coconut juice. Jason's older brother John, who had been sitting quiet for a while, spoke:

"Do you know anything about this island?"

"Not much," I said. "I know about the missionaries, John Williams in particular, but not much else."

He smiled.

"I read the Missionary Book a few times," he said.

"The missionary book?"

"Yes, it's the logbook they kept here on the island, it's a very interesting document and we learned as much about their lives here as about ourselves. I say short lives because they were all killed by axe, all five of them."

He spoke with an eloquence and ease that impressed me and I knew of course that he had been educated at a respectable school in Vila. John was about fifty, but looked fit, like most Ni-Van. He had a proud beard which was well-trimmed and big black eyes, inquisitive and intense.

I liked John. For some reason Jason looked much older although he was the baby brother in the family. And I couldn't really take him seriously, especially after calling his son after Bush. But John seemed to me mature and wise.

"You know Williams wrote in the Missionary Book that the Ni-Van are easy to deal with and friendly as long as they talk. It is when they go silent that you have to worry, because once they go silent there's no way of telling what they'll do next," he said.

"Did they eat him?" I asked.

He looked in the ground.

"I think so."

He seemed embarrassed and I thought his voice quivered a little.

"It may be a curse. You know, we call Dillon's Bay Martyrs' Bay as well. We feel bad about the past. Maybe it's because what we did that nothing works on this island. We have no development, no money...now we have this truck on the island but before we use to carry our sick children in our arms all the way to the airport, eleven kilometers."

We stood up and jumped in the back of the truck. The driver accelerated downhill and soon after we could see the huts in the village.

"Williams was killed on that rock there, across the river. They carved the outline of his body on the face of the rock before they ate him. We'll go there tomorrow so you can see."

There seemed to be a heavy air in that village. I could see women moving around in the dark, windowless huts but as soon as we passed they vanished. I felt watched though, I felt those dark eyes following me as I walked by accompanied by the leaders. There were maybe ten huts placed among frangipani, magnolia

trees and coconut trees. Few meters away the sea was crashing on a rocky beach and there was open water to west, all the way to the Great Barrier Reef.

Chief William Mete came out of his small house and greeted me. Half his face was paralyzed so he spoke with half-lips and expressions on his face, a smile or a frown, were visible only on the healthy side while the other was hanging like a piece of dead meat.

I was given the "guest house," a tiny construction built of coral and sand, with slats in the windows and beautiful conch shells adorning the walls. Inside there was a bed, a table and a chair. Then, to my surprise I discovered there was an adjacent kitchen with a small stove and another wooden table and chairs. It was a jewel and I was happy to spend my days in that little house, the house of sand and coral.

I left my bag in the room and joined the others outside for tea.

"You know Christian, John Williams came here on November 19, 1839 on a ship called *Camden*. It was he and another missionary called James Harris. They were both killed within a few hours after landing here."

I thought about my landing on a beach the year before and how different my experience had been from the first Europeans that reached the island.

"Look Chief," I said, "I'm not a missionary. I'm here to see how you live."

He sunk in his thoughts for a while then said:

"But you what your brother told us last year? That everyone is a missionary one way or another, everyone trying to sell their ideas, their beliefs, their principles."

Then he paused, as if to let those words sink in with his audience because by now a crowd had gathered to listen in to our conversation.

"We're all Christians now and we're grateful for that, Thank God."

I wanted to tell him that I did not want to sell any ideas or principles, or any beliefs, that I was more interested in recording their stories than anything else. But then I realized it would be a lie, because I knew I'd write about it all, and so propagate an image, an idea about these people and this place, and thus become a missionary myself, a missionary of letters. The Chief, or maybe my brother, made sense.

But at the same time I couldn't help being disgusted with the Christian invasion of the South Pacific, and the overzealousness of those narrow-minded soldiers of European and American Christian churches arriving in the islands to rid the savages of the devil residing in their souls. Even today they're everywhere, on EVERY island in the Pacific, from the young elders of the Mormons to Pentecostals, Jehovah's Witnesses, Adventists and so on, and they run programs with the efficiency of a corporate project manager, that is by milestones and deadlines. But I chose to remain silent and keep those thoughts to myself.

They were eager to know the news from the world out there and I tried my best to give them an idea of what was going on abroad without sounding cynical or pessimistic. I told them how fortunate they were to live in a peaceful place like that, fishing every morning on the reef, working in their gardens and living a healthy life while most of the world was plagued by wars, famine, disease, economic depression and slavery. They all nodded in agreement. They knew despite their hardships they were happy.

The crowd split at the Chief's signal and all went to their huts for the afternoon rest. I lied down in the wooden bed and daydreamed about living on that island forever, listening to the wind rustle through the palms outside the windows and the surf landing on the beach.

The next day they John waited for me on the beach and a motor launch drove us along the coast to Suvu Beach. The boat slalomed between gigantic coral heads that looked like colorful oversized mushrooms in the crystal clear green water and, with the outboard lifted out of the water, we landed on a white sandy

beach. There was no one in sight. The beach was flanked by high cliffs on each side and clusters of coconut trees rose high above the wild brush at different elevation levels. Behind there was the mountain that we descended in the truck coming down from the airstrip the day before.

John and Simon, the boat driver, got their machetes out and started clearing a path as we slowly climbed uphill. We came to the face of a cliff and John removed the branches and stones covering the entrance to the ancestral cave.

"We put these so children don't fall in when they play around here," said John. The he kneeled outside of the entrance and started chanting a prayer, asking for permission to enter the resting place of ancestors, friends, family and enemies, all gathered in the same place for eternity.

We crawled through the small opening and descended into a large cave. John moved the flashlight around and mounds of human bones appeared all around us.

"They're all our brothers and fathers and men we killed in battle."

The femur bones were large, indicating the impressive size the ancient Ni-Van must have been.

"So all these people were eaten up by other people," I said.

John put his hand on my shoulder and said:

"Well, you're my brother, if you die, it's an honor to eat you. If I kill you in battle, again it's an honor to eat you. You're still my brother. That was the idea, but nowadays they do this no more."

We climbed out of the cave. Little snotty George, named after George Bush, was crying outside the entrance. He had walked through the bush to find us and got scared when he saw the cave open. Children were always scared of the ancestral spirits. A year before I was sitting in the cockpit of my boat when a young boy quickly climbed up and sat down next to me, shivering and looking around with a petrified look on his face. It had startled me to see this shiny black body emerge from the ocean and sit next to me for thirty minutes without saying a word, just panting

heavily and looking around, as though he had been chased by invisible ghosts.

I tried to calmly speak to him and ask him what was the matter and in the end he told me he was diving for fish at the reef and he felt the spirits moving around the anchorage, angry spirits and very powerful. So he had to find another human being to sit with, he could no longer bear to be alone with them.

John took little George under his wing and calmed him down with a soothing voice.

We walked back down to the beach and jumped in the ocean, clear as a mountain well, populated by fish of all colors, stingrays and small reef sharks, moving in and out of the submarine landscape built of live coral, sand and granite rock.

In the evening we made several small fires out of coconut husks around the cliffss and soon after the coconut crab came out, dizzy by the smoke, tranquilized and easy to catch. They were big blue coconut crabs, a real delicacy anywhere in the world, but as easy to pick here as a cucumber from the garden. The boys made a bit of rice in a pot, boiled some coconut cream on top and grilled the crabs over the fire. It was one of the best meals I ever had. The stars were out; the sea turned into phosphorescent ink and the surf was frothing white. There was no electricity on the island so when I say the stars were out, I didn't mean the way you see a star or two out of a parking lot in the middle of a city, no I mean millions of them, galaxies floating in snowdust, giving you the feeling that you were on the edge of this planet looking down into Universe, almost falling off this edge, giving you a vertigo people in the city experience only after injecting chemical substances in their bodies.

That was when I first realized I was there. The depression was gone, the loneliness was gone, and my soul had finally caught up with my physical location on Earth. I was there.

"HERE. NOW." I said.

"Hmm?" asked John, with a sleepy voice.

"I'm here now, John. And it feels good."

This had been a big problem for me. The "now" was an elusive point on my axis of time. I lived most of my life in my mind, either in the future or in the past, but I could never say I was happy because I was never there when it happened. For the first time ever, that night in Erromango time stood still and I was allowed to join it before slowly walking hand in hand from there on, feeling the present and understanding its importance.

Three days later I flew back to Vila in what the locals call "the biscuit tin." It was a tiny plane with only eight seats and what impressed me was that a twenty-year-old girl from New Zealand flew it. I was so impressed that I thought I'd make a joke so I patted her on the shoulder and when she turned I said:

"So where's your daddy?"

She gave me a stern look and wanted to tell me a few things but I saw that she repressed those words and replied politely:

"We'll be fine, Sir, no worries."

There was only one other passenger in the back, a boy who had slashed his ankle with a machete and was going to the hospital in Vila for stitching.

The girl pilot turned the plane and accelerated on the grass strip without any hesitation. At the end of the runway there was nothing but sky and water, as the cliff plunged down into the ocean, which pounded it relentlessly. We remained suspended over this separation line between the foam of the crashing waves and the black cliff walls until we gained more altitude and could see the entire island. Incredible melancholy views of that South Pacific island and the gentle ocean swells rolling beneath us and the gracious neck of this girl, with blonde fluffs shining in the sun, made me daydream in another one of those naturally-induced highs. The trip took forty-five minutes but it could have lasted a lifetime. The girl landed the plane perfectly and taxied outside the small airport. I took the boy in my arms, helped him off the plane and called for the staff to bring a stretcher. Then I stopped by the pilot's cabin window and apologized for the bad joke.

"I really wanted to give you a compliment because I was impressed. I'm even more impressed now, and envious that at your age you fly planes between remote South Pacific islands. I navigated halfway around the world but I cannot feel but admiration for what you do. Please forgive my patronizing and sexist comment."

She smiled, pleased to hear that.

A few days later I heard from a German pilot that had a yacht at the waterfront that the girl was the youngest pilot in the Air Vanuatu fleet and would become the youngest to fly jet planes within a few months. I later saw her at Nambawan Café, wearing a light summer dress and looking very pretty, like a worry-free teenager, very different from the uniformed girl I had seen earlier.

I went to *Au Bon Marche,* the second supermarket in Port Vila, which the locals called Nambatu and bought blue cheese, and a baguette for lunch and a sirloin steak for the evening barbeque. I stopped at the market to buy pamplemousse and pawpaw. The market in Port Vila was a beautiful cultural event that brought the entire community around it for six days every week. Women from all islands came there with their fruit and vegetables, crabs and fish, almonds and firewood, palm leaf baskets and coconuts. They arrived Monday morning with their children and left Saturday night, thus keeping the market open for twenty-four hours a day, six days a week. They slept on straw mats under the tables and earned an income for the family. The women kept the only economy the islands had going, while men drank the kava under palm trees in the nearby park facing the ocean. Sometimes I'd go at midnight to get fresh fruit at the market, something I could never do in Canada.

I went back to the boat and after stowing the food I dove under the boat to clean the propeller and hull of shells and sea grass. As I was coming up for air I saw a large shadow at the surface and I froze. A four-meter dugong was swimming next to

me, his moustache reminiscent of Lenin's. I was glad he was a vegetarian.

September 26

Today at the Nambawan Café I met the Swiss sailor Pascal Voiblet. He had sailed his 28-foot *E'Eva* alone all the way from France three years earlier, and was now accompanied by a pretty Quebecoise by the name Maude Pomerleau Bessette. I had a chat with Pascal alone first, talking about weather forecasting, voyaging solo, boats and places, we discussed about the option of going sailing to China, Vietnam, and Indonesia, then Maude came from a walk in town and she told me she missed Montreal but didn't know when she'd be able to return there. I liked this couple; they were good looking, funny and well read. As it turned out, Pascal was a mountain climber, sailor, hang-glider pilot, a world adventurer. I liked his quiet determination, his slow talk, and his late answers, as though he was thinking before, during and after he spoke. He seemed to me the rational type, the kind that turns off the emotional faucet to do what he sets out to do. Maude on the other hand was a smoking volcano, ready to erupt at any moment. I liked her sense of humor, her egoless attitude, her happy-go-lucky clueless-ness. I liked her accent too. She used to call Pascal, "my leetal Ponee."

We clicked instantly and we decided to meet at the Royal Bamboo, the Chinese restaurant, the same night. I had had dinner there many times and the Chinese owner and his wife treated me like a regular. We ordered lots of food, spicy beef, island cabbage, chicken curry, seafood chowder, wine and beer. As we were sipping the wine, Harald and Andrea off *Vivaci* showed up. Harri was a seventy-seven year old former surgeon, sailing around the world in a steel cutter, and Andrea maybe forty, both Germans from Bavaria. They were also very well read, in fact we started talking about books before we even got to know each

other. We started at Paul Theroux and ended up at Maugham, with his *South Sea Tales*.

It was good to have the company of those pleasant people with whom I could have an intelligent conversation. It was a good break in my self-imposed isolation and their presence energized me. With the wine flowing, stories started to emerge and I went quiet, recording.

Pascal talked about his aluminum boat and how he bought it from a French musician in the south of France. Pascal had lived in a Volkswagen minibus for two years, saving money for the world voyage. He had a well-paid job as an engineer for a famous Swiss watchmaker, but his colleagues and managers looked mildly amused at him as he drove every morning through the gates of the company in a hippy car, and wearing a black suit. He parked in different locations in the woods, places with a good view and privacy, where he could plan his escape and dream of oceans, continents and remote atolls. Then an American company bought the Swiss watchmaker and they eventually moved all production to India. Swiss watches, made in Mumbay. This was the brave new world of our times.

The radio started playing Edith Piaf. Maude's eyes filled with tears.

"Oh, don't mind me, I just remembered something," she said.

Everybody waited.

"Well, okay, I was once working in a garden in Quebec City and there was this French lady wearing a beautiful summer dress with bright flowers embroidered on it, and a large straw hat. She was old but you could tell that she had been an incredible woman in her days. Then, just like now, someone played Edith Piaf's *Milord*, and she stood up from the tomato rows and remained immobile for the entire song. I went to her and saw that she was crying. She hugged me and told me she hadn't heard that song since World War II. She had lost her lover in that war and the song reminded her of that episode in her life. That's all."

We were in the South Pacific, in a Chinese restaurant, a group of Europeans listening to Edith Piaf and telling stories of the Second World War.

Tears. Tears and laughter.

We ordered vanilla ice cream. Ten minutes later the Ni-van girl came back and said:

"Sorry, we have no more bananas."

We all looked dumbfounded for a second, then everybody burst out laughing.

"No more bananas?" shouted Pascal. "You ran out of bananas? This of all places should have bananas! This is unacceptable."

And there was more laughter.

All night and the following morning the rain fell like theater curtains, thick, heavy windborne rolls of water closing an act and opening another. Low clouds flew west with the trades, and there was a smell of moss and humid earth in the air. I walked to *Au Peche Mignon* for a cappuccino and a croissant, then, picking my weather window between rain squalls, ran to Nambawan Café to Skype with my wife.

I sat down with the regular limejuice and a cigarette and I saw a small sail at the horizon, slowly disappearing in the drizzle. *E'Eva* was no longer at anchor and I thought that might have been them, Pascal and Maude, heading west to New Caledonia and beyond. There was something sad in that picture, perhaps there was something sad in my eyes as well, but there was also something beautiful in that sail melting with the horizon, because it made me think that our life was just like that, a series of arrivals and departures and in between some special human exchange, brief relationships, commerce of thoughts and emotions, and then everybody leaves. Everybody leaves tomorrow, and when the shore disappears behind, one remembers every word that has been said, every smile, every tear, and everything is re-played over and over again, and that's how we learn from the people we meet and that's how we remember.

I opened Krishnamurti's "The Only Revolution," and read:

"Meditation is not an escape from the world; it is not an isolating self-enclosing activity, but rather the comprehension of the world and its ways. The world has little to offer apart from food, clothes and shelter, and pleasure with its great sorrows.

Meditation is wandering away from this world; one has to be a total outsider. Then the world has a meaning, and the beauty of the heavens and the earth is constant. Then love is not a pleasure. From this all action begins that is not the outcome of tension, contradiction, the search for self-fulfillment or the conceit of power."

The book was a present from Pascal. I read it as a message from a friend.

I switched on Skype and called my wife. While talking to her about the horrors of the civilized world, a group of newspaper boys arrived and after doing the rounds amongst the café guests, they sat at a table near me and checked the pizza menu written in chalk on a big blackboard behind the counter. I watched them closely, the way they counted their money, calculating the price per slice of pizza and discussing which topping they could afford.

"Are you boys hungry?' I said.

They nodded shyly "yes."

Josephine, the girl that always served me, (I felt like the strange Melvin Udall played by Jack Nicholson in *As Good As It Gets*) was just passing by and I stopped her (grabbing her arm, as always) to order two large pizzas for the boys. She took the order and thanked me for my kind heart. That made me laugh, but I didn't say anything else, since my random acts of kindness can hardly be assigned to a good heart. A woman sitting nearby stood up and asked the boys what they would like to drink. Obviously she read into what was going on and thought she could extend a hand of her own.

She looked at me and smiled. I smiled back. She was a sailor from Alaska, cruising the world with her husband. Two days later, they sailed past Nerissa K and waved as they made their way out of the harbor, heading for New Caledonia.

Josephine came back with two pizzas and the boys dug in with a vengeance. It was great watching them eat, listening to them chatter in Bislama.

"Me wanted toktok with da Boss," one of them said. He was the leader, confident, street-smart and eloquent. When they finished he came to me and shook my hand, then all the other boys followed suit. I signaled to them to go thank the lady as well. They did, then there was some commotion in their group and a big argument started. Their money disappeared. Everything they had collected that morning was gone. I stood up and started looking around their table, out in the grass, checked their pockets. The lady joined the search, Josephine too, and soon after most adults in that café scoured the grounds for the children's money.

"Da Boss is gonna be mad," the leader said.

They got a free pizza and a drink but now they had to work weeks to pay back the lost money. The somber mood did not last though. That's how the Ni-van deal with the vicissitudes of life. Twenty minutes later all the boys jumped off the breakwater and swam in the warm sea. One of them wore a black T-shirt with the logo:

"Play Nice."

That evening I was invited on *Vivaci* for dinner. The sky had cleared and the stars were out again, like distant lighthouses sending Morse signals to Earth. It was a calm night and the water in the bay was flat, and the boats looked glued into it, immobile, like sitting on cradles on hard land. A half-moon smiled down on us as we sat around the wooden cockpit table on *Vivaci* and drank *Kirschensnaps*.

Andrea sat on a traditional Fijian coconut scraper, which is a plank of wood placed on a step or chair, and scraped the halved coconut against metal blade attached on the other end of the plank. The scraped coconut is caught in a bowl beneath this. Harri then squeezed the fruit in a fine cloth and the coconut milk

dripped in a bowl. The mussels were steamed in white wine, then the coconut milk was added and rice. This turned into a feast and as the night wore on, spirits rose and stories were born.

But I had this image stuck in my mind for long after the evening was over, the image of this woman scraping the coconut, legs apart, her blonde hair tied at the back of her neck, except a streak dancing wildly across her face as she stroke the halved coconut against the knife, beads of sweat on her forehead. There was something very erotic and very primeval about that image, and I wanted to immortalize it as a painter would, or perhaps a good photographer. But I had only words to work with, and words are sometimes not enough, or maybe the writer is not talented enough to draw that picture.

"There's love in making this food, no?" she asked.

"Harri feels alive when he lives like this." She looked at him and I knew she loved her old sailor, and she admired him.

That night I found out that he had been a famous surgeon in Bavaria, a very rich and successful owner of a private hospital and a very respected professional. Then he invested millions in a golf course in the Dominican Republic, and a smart crook managed to steal all his money. His wife died of brain cancer, then his son suffered from the same illness and died too. Andrea used to be his son's friend and that's how they met, during those months before his death, spending time together, trying to make sense of a senseless tragedy.

That changed his life. Harri bought *Vivaci* and went sailing around the world. There were no money, no possessions except the boat and a very modest pension, but he was happy now, he lived a simple, fulfilling life and at seventy-seven he lived more intensely than most people half his age.

Andrea had worked in theater and film and had aspirations of becoming a screenwriter someday.

These were the kind of people you would meet out there. People with beautiful life stories, a gold mine for a wannabe writer like me.

October 1st,

I have been moored in front of the "Waterfront" restaurant for sixty days now, and every night, and I mean every night the band plays exactly the same songs in exactly the same order, at exactly the same time. I feel like the guy living the same day over and over again in "The Groundhog Day." I couldn't sleep so I went in the cockpit to smoke a cigarette and drink a little Port wine. On Iririki, on the opposite side of the mooring field, there is a tall bonfire on the beach, strong, black, shiny Ni-van boys dancing like warriors, torches lining up the alleys and slim women gracefully walking in long evening dresses. Women, women, women.

You should hear me sigh.

The world's financial markets are in freefall. The news agencies use words like "financial meltdown," "credit crunch," "disaster," "world recession," "another 1929 depression," and so on. Yet none of that is in any way visible here in Vanuatu. It's like the ethereal voices come from another planet. Here the children are playing on the waterfront, boys are jumping in the water, girls are laughing at them while eating pawpaw, the women are selling their veggies at the market, and the men are drinking their kava in the shade of palmettos and banyan trees. Every day the sun rises and the clouds race west and sometimes showers of tropical rain cool off the islands, bringing forth a fragrance of frangipani, bougainvillea and hibiscus. Every day here is almost an exact replica of the day before, but because the day satisfies the basic needs of people, it is not monotonous, but rather its routine brings a sense of comfort and security. Vanuatu is to a very high degree self-reliant and remains unaffected by the moods of Wall Street. It made me very happy to realize that globalization had failed here and that there are places on this planet the tentacles of greed could not reach.

But unfortunately the situation of the poor around the world turned from bad to worse. Before this crisis eight hundred million

people of the world were starving, now the numbers grew to more than a billion in just a few weeks, according to the BBC. I listened to the radio program every day and took notes in order to understand the absurdity of the situation. One day I wrote down five consecutive news pieces:

First, the news anchor talked about a Muslim in a mosque in Africa standing up in front of the congregation saying: "Everyone please look at me. My children haven't eaten anything since yesterday. I'm not asking for your money, but could someone give me a little flower, please? My children are starving." You could hear in the man's voice that he had probably never asked for a thing in his whole life, until that evening's prayer.

Second piece focused on slavery in Niger. 850,000 people were slaves in that country although slavery had been abolished years ago. Almost a million people were sold like goats, beaten up, exploited like animals, raped and even killed if they ran away.

Third, a new business idea: a company from the States turns human ashes into pencils. The relatives receive about 250 pencils per body, the carbon core being built by the human ashes, which of course are rich in carbon. People pay a fee for that heartfelt souvenir from their loved ones.

Fourth news item announced a German billionaire buying the tattoo off a man's back for one million Euros. The contract stipulated that the man had to exhibit his body art three times a year and upon his death the owner will remove the painting from the body, meaning the skin from his back would be removed, dried, stretched on nails, then rolled like a canvas or pinned to a wooden frame as with any painting.

"I'm just a frame holding a work of art," he said. "Upon my death the owner will remove the canvas and preserve it as a collector's item."

And finally the fifth piece focused on twenty Afghan refugees that had been killed upon their return to their homeland after the Australian Immigration Office paid them 2,000$ cash and told them they would be safe if they went back home. The refugees

never stepped on Australian soil but were part of the so-called "Pacific Solution," where refugees are held on the island of Nauru in the South Pacific before being extradited to their home countries. Three of the dead were children.

These were the news from the brave new world of our times. And, at the end, a little joke from the BBC.

Question:

"What is the difference between a pigeon and a banker?"

"A pigeon can still leave a deposit on a Ferrari."

Are you laughing?

I decided to stop listening to the news. What was the point?

That evening I went to Chill, a trendy restaurant on the second floor of a building overlooking the harbor. I hated eating alone, but it gave me an opportunity to study people and take notes. I ordered a beef fillet (Vanuatu has some of the best beef in the world) and a glass of wine and watched the big, long barracudas hunt in the submerged light below the restaurant.

A young woman and her lover entered through the glass doors of the restaurant and were placed at the table in front of mine. Dark-haired, handsome and athletic, the young man had the body of a swimmer. She was curvy, okay maybe a bit plump, but she had very fine facial features and perfect skin, which is rare in sun-scorched Australian women. I liked her aquiline nose and ivory sculpted cheek bones, lovely delicate fingers, and I imagined a Duke of York convicted for murdering a rival to his beloved lady, chained to the gallows of an English ship and sent to Australia two hundred years earlier. And there she was, the granddaughter of an English duke, now in love and on her honeymoon on an island in the South Pacific, next to her handsome lawyer-to-be, Mr. William Fitzroy.

I was doing all these projections while mentally noting the details of those two characters, all the time pretending to watch the rugby game that was on a flat screen TV above their heads.

I could see that she was in love with him. She watched every move he made, (what he ordered, how he was sipping his wine,) with the attentiveness and concentration of a mother watching over her son. She searched for his eyes and once in a while when he met hers, a bright, loving smile lit her face, as if saying, "I have chosen you out of millions of men out there. You are mine now."

But he seemed less enthralled by that romantic setting. In fact, he seemed a bit embarrassed, and forced a smile once in a while, as if he had put himself in a situation and was wondering how escape from it. She spoke quietly and he pretended to listen but looked over her head at the rugby game. I pretended to watch the game but was in fact listening to their conversation, studying the dynamics between them, while he pretended to listen when in fact he was watching the game.

This voyeuristic moment gave me great pleasure because I had always been interested in the story behind the cover of appearances, and these people, which I had never met and probably never would, became part of my story for that one evening. Most of the things I projected onto their lives were most probably wrong, but I didn't care, as a writer they gave me two characters and a story and that was more important to me than cold facts.

So I continued my game with a more prophetic vision. I saw them ten years later, living in a Sydney suburb in a half a million-dollar house, with two freckled, red-haired, noisy children, one boy and one girl, both slightly overweight.

Every morning, after a shower, he gets into his suit and rushes out with a hot cup of coffee in his hand, chased out to the driveway by his wife, who packed his favorite lunch sandwiches and wants a goodbye kiss. He gets into his BMW and speeds on the highway, talking to his office partner through his earpiece.

She wakes up the kids, feeds them with pancakes and maple syrup and milk, and then drives them to school in her van. On the way back home she stops at the grocery store and ticks off every item on the list, then rushes home to do the laundry, clean

the house, pay some bills online, and finish planting the annuals in the garden. And once she takes a break, she looks at herself in the mirror and wonders how life tumbles on you like that year after year, like the undertow of high wave at the beach, sucking you under and carrying you away from shore, throwing you like a rag and it's all out of your control, because there are forces much greater than you that pull you away from your dreams. And she thinks, well, there are the kids now, and they are the priority and until they're settled Bill and I will have to make sacrifices. Then there are the mortgage and all the debts of course, but maybe in twenty years Bill will be an associate and the kids away from home and…twenty years, she says, twenty years. Twenty years.

I looked at them and I felt guilty. She took his hand and looked in his eyes, her pupils moving quickly, as though she were searching for his soul. He smiled and kissed her hand.

What can possibly poison young love? Neither I, with my cynicism, nor anyone else with a lifetime of experience could extinguish that flame. Because nothing stands in the way of the mighty avalanche of love.

I was surprised at the clarity of thought that emerged from those still days of my solitary confinement. I'd lie down in my bunk for hours, thinking about nothing, very Zen-like, absolutely devoid of thought until suddenly memories, ideas and THOUGHTS would spring to mind like impalas darting out of the African bush.

One day I thought about my playing the guitar since I was ten years old. Playing the guitar has always been connected with sadness for me. I played when I failed exams as a student, when I lost girls I was in love with, when I felt lost and confused and unable to cope with the rough world I lived in.

When I was a teenager I became a rhythm and blues guitarist and more blue notes kept me alive during those sleepless years. I was quite good and at the height of my "musical career" I recorded an album, was played on the radio and later on played

concerts in Sweden. But I realized that music was something else to me, it represented a medium where I expressed my sadness, that overwhelming feeling of loss and mortality. I see humanity and beauty through sadness, for me this feeling is not at all negative, as is portrayed in the western world. I believe in short snippets of happiness, I believe in laughter and joy and I do see life as a sumptuous banquet, but I think the idea that we have the right, the we should demand permanent happiness is preposterous. I see sadness as awareness of the ephemeral nature of life. I am overwhelmed by a sense of sadness when I see a gannet soaring over the ocean, because I know that one day both my life and the gannet's will end, and the only thing left will be a memory imprinted somewhere in the collective human conscience. And hopefully one day a young man will watch another gannet fly above the fuming ocean and cherish that moment as much as I had.

Sadness is good, I don't know what people are so afraid of, taking drugs, going through therapy, sadness is part of human life. It made me laugh when I heard Zen Master Roshi telling Cohen:

"Leonard, you should sing more sad songs."

And that day I was sad because I remembered what had happened exactly twenty years earlier, when I was a young university student in a city in northern Romania. That precise day, twenty years earlier, I was asked to stand up and recite the Great Leader's speech from the XIII Congress of the Communist Party. I was in an amphitheater full of students, surely over one hundred young men and women, most probably more concerned with the subjects of love and adventure rather than politics.

I stood up and, again devoid of thought, with a moronic face, I declared I was not in the least interested what Ceausescu had to say because I had made up my mind and was going to leave that godforsaken country anyway. There was a shock wave going through the rows of students, murmurs traveled across the large

room, escaping through the open windows like a hummed quire. I looked outside, it was a beautiful late fall afternoon, and the birch trees were white and skeletal, and the few leaves left were dry and brittle, and yellow against the crisp clear sky of November.

There are turning moments in life and I knew that was one of them. Time slows down for a while, and pupils grow larger, but soon after everything accelerates back to the hallucinating speed of reality.

I was asked to leave the amphitheater. By the end of the day I had been expelled from the oldest university in Romania. I went back home in the mountains and caressed my wife's belly, which was carrying my son, Paul. Weeks later the Revolution ignited in the west and days later the dictator fled in a helicopter from the roof of the Parliament Building in Bucharest.

Fast forward six months, my son was born, and three weeks later I was on a train crossing Europe, on my way to a new life.

That was twenty years ago.

So speaks the master:

"When I was very young and the urge to be someplace else was on me, I was assured by mature people that maturity would cure this itch. When years described me as mature, the remedy prescribed was middle age. In middle age I was assured that greater age would calm my fever and now that I am fifty-eight perhaps senility would do the job. Nothing has worked. Four hoarse blasts of a ship's whistle still raise the hair on my neck and set my feet to tapping. The sound of a jet, an engine warming up, even the clopping of shod hooves on pavement brings on the ancient shudder, the dry mouth and vacant eye, the hot palms and the churn of stomach high up under the rib cage. In other words, I don't improve; in further words, once a bum always a bum. I fear the disease is incurable. I set this matter down not to instruct others but to inform myself." John Steinbeck, Travels with Charley In Search of America (1962)

November 1, 2008

The big day has arrived. Falvio and Chris are expected to land in Vila this afternoon. My lonely days are over. Nerissa K and I would have to adjust to having two more guests onboard. A few days ago I started checking out the weather forecasts and I felt certain nervousness at the thought of the passage south. I had had a quiet life for three months and now the roar of the ocean stirred inside me. The latitudes of silence were no longer silent, and the further south you get, the greater the thundering of crashing seas. This was to be the toughest passage I had ever done and we were all aware of this. Flavio and Chris were relaxed on arrival, but cautious and apprehensive about the crossing south. I made sure they understood beforehand what they had signed up for.

Three days later, Nerissa K left Port Vila after one year of sad idleness. We steered her out to sea again and headed south, to the great Maori lands of the Southern Ocean. The sun was shining, the waves were lap lapping against her topsides and we couldn't take our eyes off the blue, hazy horizon. Chris stood at the bow for a long while, entranced in the experience of his first ocean passage. Then, he turned to me and said:

"Thank you, Christian. Thank you for offering me this incredible experience."

It was a soft start to the hardest passage of my sailing career. What followed was a grueling slog through head winds, rain and wind for most of the thirteen days it took to reach New Zealand. Three days after out departure we were already wet, exhausted and feeling miserable and we were still looking at Tanna on the port tack. By the time we left Vanuatu's territorial waters and headed offshore we were already fed-up with everything onboard. We were lucky to get three days of calm in which time we dried everything up, got some rest, re-grouped and re-charged our batteries. Then the rest of the passage was just what we had before the calm, only colder, rougher and more uncomfortable

than ever due to high head winds, smashing into steep seas and getting everything inside drenched in salt water. Chris slept in the V-berth and had bruised ribs from being lifted from his wet bunk and slammed hard against it as we were beating into the seas. But my crew never complained. They put a brave face and clenched their teeth, doing their duties with impressive determination. Yet again, Flavio was a genius at cooking for us, Chris helped with dishes, and both worked hard on sail changes, navigation, small repairs and everything else that's thrown at sailors at sea.

Thirteen days later a full moon came out and at midnight we saw the silhouette of the North Cape stand out against the horizon. There was a smell of coniferous plants, ferns and almonds. That smell was absolutely dizzying. It was a fragrance that blew off the land and perfumed the sea like magic potion, beckoning the sailors, inviting and welcoming them to that fantastic, mysterious North Island. They say the waters around North Cape are cursed by the Maoris, an attempt to deter the white invaders from reaching their island and even today there are people that swear by the black magic of its waters and the negative energy unleashed during storms and fog. It certainly was a rough place to behold, but hours later we saw the first lights of civilization and by dawn we entered the Bay of Islands.

Small houses appeared around the edge of the bay and we saw forests of masts in each anchorage. I had never seen so many sailboats ever before. I had arrived in the sailing Mecca of the southern hemisphere. We pulled up at the customs dock, after fighting with the strong current in Opua, and waited for Customs and Immigration. This was the end of a ten thousand mile passage and a big chapter of my life. Two years earlier I was in an office, imprisoned in a glass and steel building and dreaming of the South Seas. Ten thousand miles later I had re-gained my freedom and my lust for life. The voyage made me stronger and more confident and it gave me back something I had lost in the numb comforts of civilization. I had found myself again at sea and I realized I had become a better man because of her. And, as I was drinking

coffee with my friends in the sunlight of an early morning, I started dreaming again, of Asia and the Indian Ocean, of Africa and its alluring shores. There was a beautiful world out there and Nerissa K was pulling her lines like a young stallion, eager for more continents, wider oceans and longer passages to ride on. We would stop there in New Zealand for a while and rest.

But only for a while.